The Painter's Corner

AIRBRUSH

BARRON'S

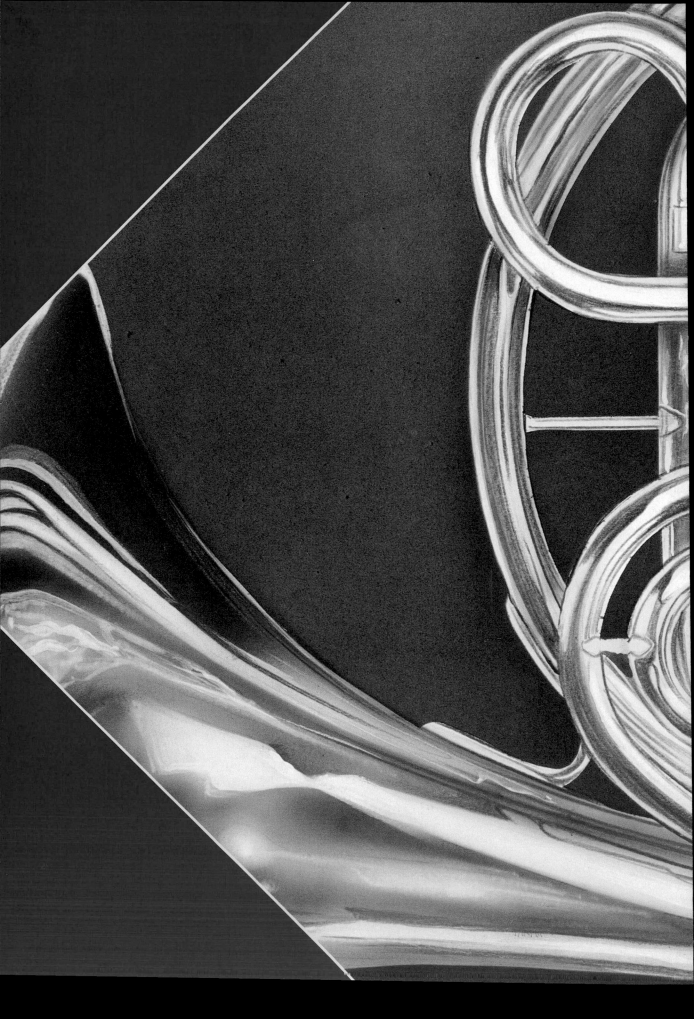

Original title of the book in Spanish: *Aerógrafo*
© Parramon Ediciones, S.A., 2003
Published by Parramón Ediciones, S.A., Barcelona, Spain

Authors: Parramón's Editorial Team
Editor in Chief: Ma Fernanda Canal
Editor: Tomàs Ubach
Photography: Nos & Soto and Lluís Borràs
Text and Coordination: Myriam Ferrón
Projects: Myriam Ferrón and Esther Rodríguez
Design: Josep Guasch

All inquiries should be addressed to:
Barron's Educational Series, Inc.
250 Wireless Blvd.
Hauppauge, NY 11788
www.barronseduc.com

ISBN-13: 978-0-7641-5703-5
ISBN-10: 0-7641-5703-5

Library of Congress Catalog Card No.: 2003107537

Printed in Spain
9 8 7 6 5 4 3 2

Contents

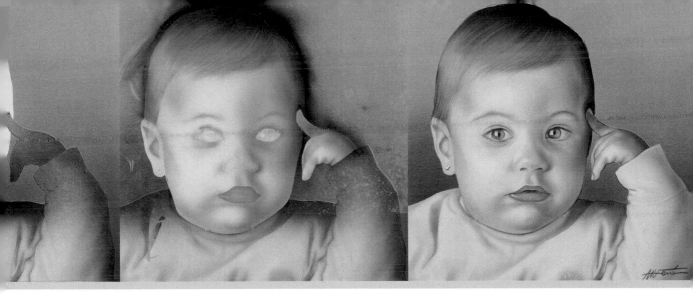

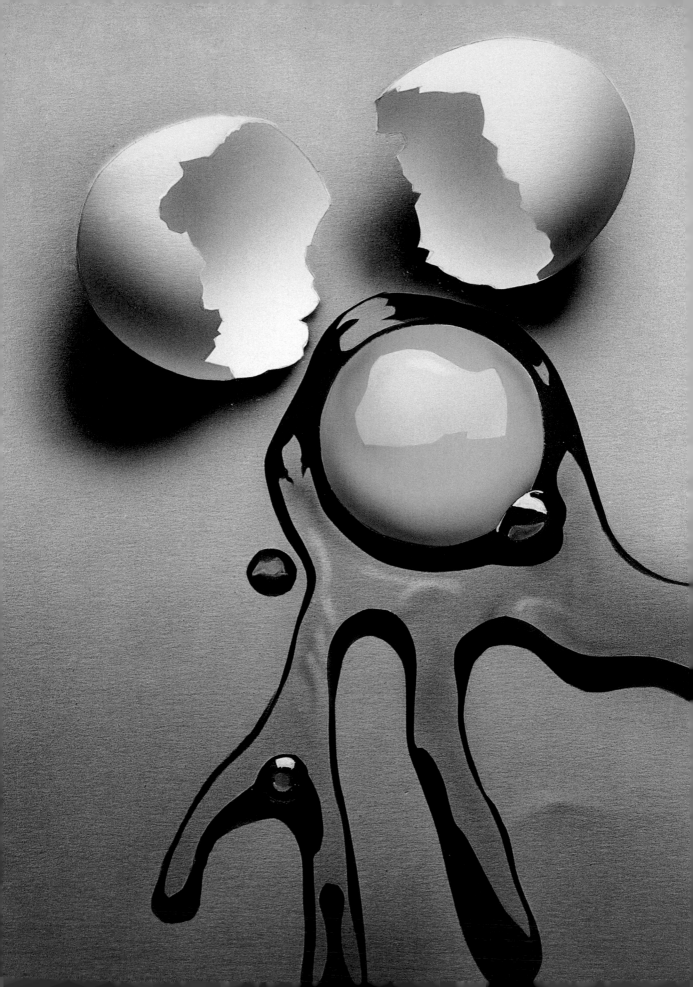

Foreword

I t's not easy to learn airbrush technique, especially since the first impression we get when operating an airbrush is that we have absolutely no control over the quantity or the quality of the paint. This impression is completely understandable, because the tool sprays a mist of paint and makes no contact whatsoever with the substrate. This can be discouraging for a person who is using an airbrush for the first time. However, after doing a few simple exercises, you will gain more confidence in using the tool.

The airbrush really makes the painter's job easier because it can be used quickly. It works by air propulsion, which carries the paint along, as with an aerosol; the artist's hand and touch control the precise quantities of ink and pressure to create everything from broad coverage to the finest lines. The effects can be spectacular, as you can achieve gradations and shading that would be difficult to get using any other technique. The color materializes in a wispy and gradual way, without marks or brushstrokes. The activating lever controls the color intensity.

In the following pages the reader will encounter the steps that led to the invention and perfection of the airbrush. This instrument has turned into an indispensable medium in the art and advertising worlds. Today, computer graphic design is being used to create many images in design, illustration, and advertising, but airbrush remains more traditional, where the artist maintains direct physical contact with the work. This makes the creations unique, original, and non-repeatable.

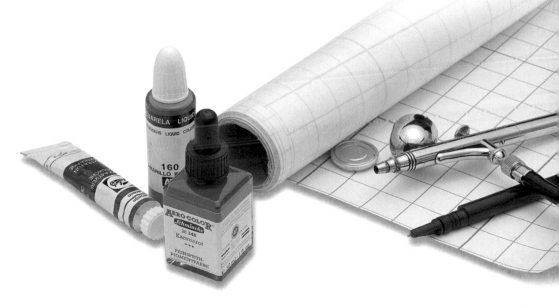

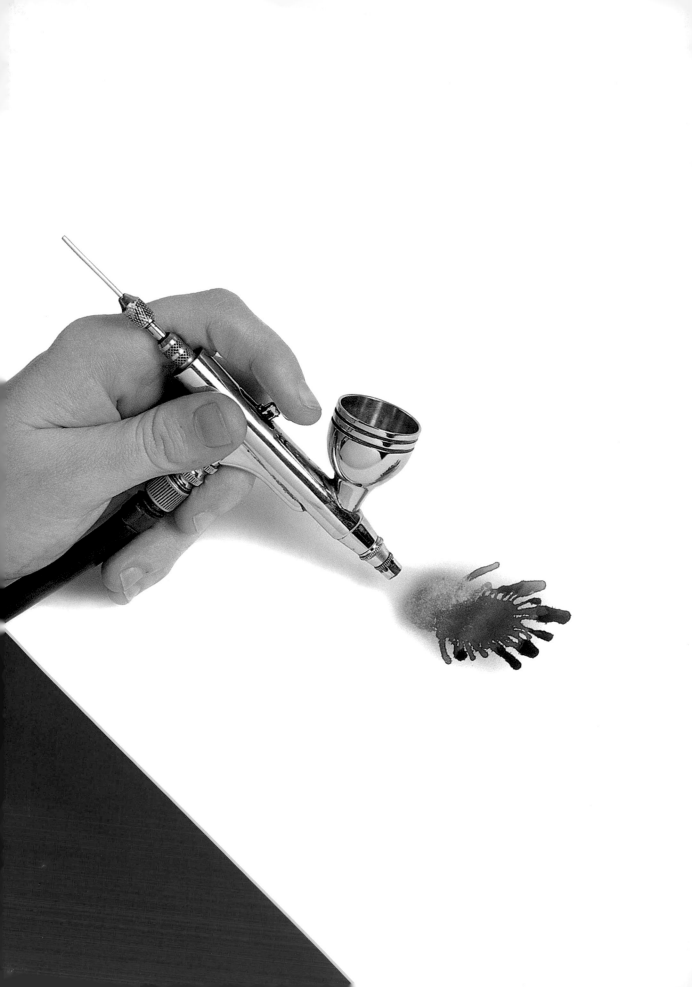

A Brief History of Airbrush Technique

At the outset, airbrush technique occupied an uncomfortable place among traditional arts. In time, however, it has earned the respect of other disciplines and become essential in the illustration and advertising fields.

It hasn't been an easy road for the development of the airbrush throughout the twentieth century, since contemporary artists and movements were slow to accept its modern character and technical revolution. For some time this process was branded as being cold and impersonal, since a mechanical tool comes between the painter and the work. That restricted its use to secondary roles, such as retouching photographs, mass-producing greeting cards, filling in backgrounds, and so forth. But after World War I, movements such as the Bauhaus in Germany highlighted the importance of mechanics and technology in art and adopted the technique; thus it managed to gain entry into the artistic avant-garde. From that time on, the airbrush also penetrated into the design field, advertising, illustration, and poster art—areas where it remains an essential technique. In addition, with the emergence of pop art in the sixties, the creation of posters and record covers increased tremendously, and advertising turned into one of the moving forces of mass culture, a role that it retains to this day.

◆

Airbrush is a technique that offers all kinds of advantages for depicting any feature.

◆

However, graphic creations done on computers are now gaining ground in the advertising field; they offer greater possibilities for combining, touching up, and modifying photographs and images. Airbrush is limited to free artistic creation and illustration, since its ability to imitate any texture makes its use essential in the graphic rendering of many subjects, especially ones where photography can't illustrate what the text requires.

Illustration by Miquel Ferrón that shows the possibilities of the airbrush in representing all types of textures and features in a very realistic and spectacular way.

The Beginnings of Pulverized Paint

Sprayed images are as old as painting itself. There are cave paintings that show the application of pigments sprayed around a hand in such a way that the hand created a blocked-out area and the color was applied around it. There are also quite a number of large animal figures that reveal the technique of spraying was fairly common, since it allowed filling large spaces rapidly and efficiently. In many compositions the outline was done with a brush, and with time the inside was sprayed repeatedly to reinforce the color. Pulverized paint was applied with a hollow bone or reed.

After these primitive methods, the technique of spray painting became more sophisticated. Some works show misty backgrounds and textures with no trace of brush strokes—a blowpipe or mouth atomizer was probably used. This tool, which was traditionally used for both filling in backgrounds and fixing and varnishing paints, involves two metallic tubes that form a ninety-degree angle; one of the tubes is submerged in the paint, and the artist blows through the other, and that way the paint and the air mix and vaporize the pigment. Clearly the main problem was the effort required to fill in a large surface, and more efficient air propulsion devices didn't appear until modern times.

THE BERNOULLI PRINCIPLE

An atomizer, like most airbrushes, paint sprayers, and aerosols, functions according to the Bernoulli principle. The air that enters the tube is under greater pressure than the outside air, and that makes the paint rise from the reservoir to mix with the air and produce an abundant, uniform spray.

The cave of Rio Pinturas in the Argentine Patagonia. This is a first approach to airbrush technique using a very rudimentary pulverizing of paint. The outline is created by using hollow bones or reeds and blowing pigment around the area blocked out by the artist's own hand.

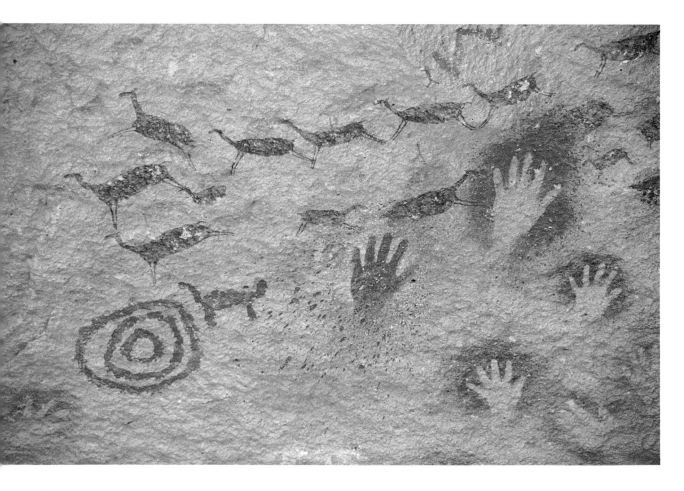

The Invention of the Airbrush

The first airbrush was invented around 1893. The experiments carried out by the American watercolorist Charles L. Burdick, who was trying to discover a tool that would allow him to apply several layers of watercolor without affecting the underlying color, culminated in the discovery of a device that he named the airbrush. Burdick patented the apparatus and did several works using this system, but they were always rejected by the national Academy, which didn't recognize the process as a new technique in painting. Despite that, instead of becoming discouraged, the artist traveled to the United Kingdom and established himself there, opening an airbrush factory named Fountain Brush.

Charles L. Burdick's first products were sold using graphic images that announced a new tool for creating drawings. The airbrush was a new invention for creating perfection in the application of color as never before, a paint atomizer that was used at a distance from the surface.

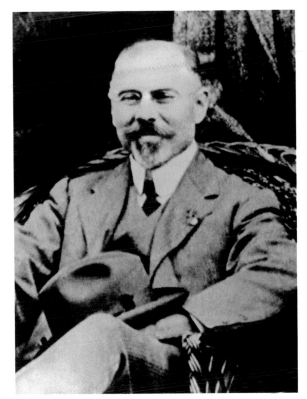

Charles L. Burdick, inventor of the first modern airbrush.

Later on, the ear, nose, and throat specialist Allan de Vilviss, an associate of Burdick's, built an atomizing system for pulverizing paints and other substances such as anesthetics, perfumes, and more.

In the 1920s, new companies were founded, especially in the United States, and a key person in the manufacturing of airbrushes made his appearance—the Norwegian and Chicago resident Jens A. Paasche, the inventor of the Paasche AB turbo, a much more highly refined and precise airbrush than its predecessors. This new system could also be applied to an air eraser, which functioned in the same way, but expelled a very fine abrasive powder that allowed the correction of errors and the cleaning of precision instruments and jewelry.

By that time, most of the airbrush types that exist today had appeared; they are made with platinum, have a centralized .007″ (0.18 mm) orifice, a needle and a propulsion lever, an air supply hose, and so forth. Over the last eighty years, only small improvements have been made, such as threaded hoses, interchangeable color cups, and especially, air propulsion systems, which have evolved along with technological advances.

The Airbrush in Poster Art

So far, we have presented the historical development of the airbrush and the difficulties it encountered in winning acceptance by art academics. However, in other areas, such as propaganda posters, the airbrush became very important. In the twentieth century, war and politics became the purview of the common people, and graphic arts were applied to informational purposes and the dissemination of ideas for society. Art took on an increasingly popular scope and ceased to be a privilege reserved for the higher classes; artistic language became more direct and transparent and lost its most superfluous details,

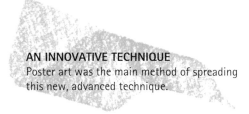

AN INNOVATIVE TECHNIQUE
Poster art was the main method of spreading this new, advanced technique.

Picture by the French propagandist Sevek. At first, airbrush was a relatively direct and rudimentary technique in comparison to today's airbrush art. Artists worked quite freely with simple images and flat colors. Later on, as the airbrush was perfected, the shapes became increasingly refined.

and as shapes became simplified and more geometrical they came to express only the basics. There were lots of flat colors with little shading, based on the primary colors plus black and white. These characteristics facilitated the reproduction and printing of posters so that thousands of copies could be made to reach any audience. Starting in the 1920s, the use of airbrushes in poster art, magazines, and other publications intensified, producing an efficient, attractive, and direct type of illustration. The images created using this technique produced great visual impact, especially with the blending and fusion of colors.

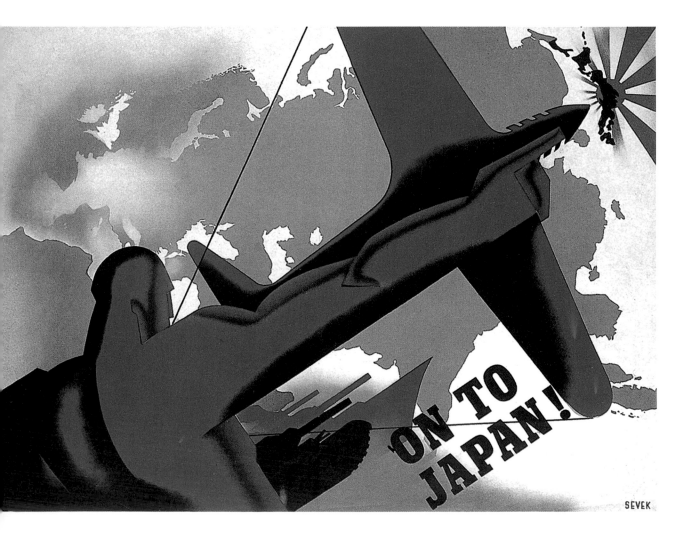

In the 1930s, shows, magazines, movies, and musical productions offered a means of escape from the tough times caused by World War I. They featured spectacular and uninhibited dancers who became prototypes of femininity and models to follow. George Petty and Alberto Vargas, two distinguished illustrators of the time, gave the airbrush a new and different focus from the previous one. Through a collaboration with Esquire magazine, they began to exhibit caricatures of people, and also beautiful, sensuous women. The success of these illustrations was so great that they were reproduced on posters and calendars. In 1953, one of the producers of this publication founded Playboy magazine, in which

Vargas' portraits of women appeared—they showed women with perfect bodies and captivating faces and hairstyles, and they became part of the American dream. The creations of Vargas and Petty were present in many other arenas, such as on the doors to playhouses, music halls, and in movie theaters. The main features of their works were the use of the airbrush and the incorporation of canons of beauty that had been adapted to the reigning fashions.

The airbrush was also used for touching up photographs; the faces reproduced in the portraits were thus delicate, free of imperfections, and in fact unreal to the point that one could say that this tool brought the image close to perfection.

THE FIRST SHAPES

With the first poster art, the airbrush was used to fill in areas with flat color; later on it was used to create a very different effect, that of volume. The women represented on posters had terrific figures. Adding color made it possible to create very realistic shapes as well as exalt the curves and the voluptuousness of the female body.

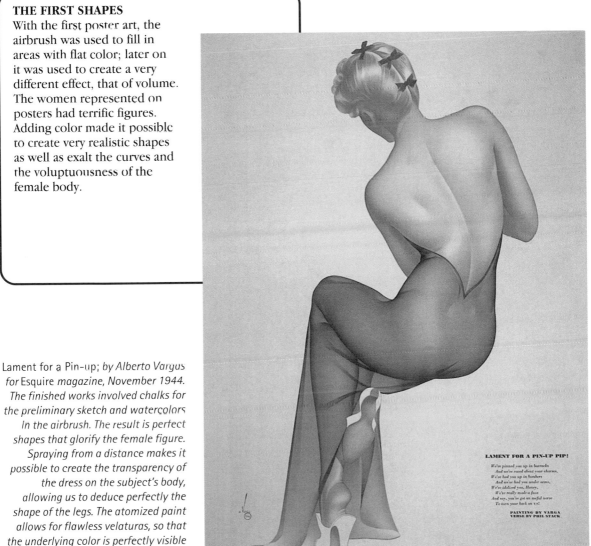

Lament for a Pin-up; by Alberto Vargas for Esquire magazine, November 1944. The finished works involved chalks for the preliminary sketch and watercolors in the airbrush. The result is perfect shapes that glorify the female figure. Spraying from a distance makes it possible to create the transparency of the dress on the subject's body, allowing us to deduce perfectly the shape of the legs. The atomized paint allows for flawless velaturas, so that the underlying color is perfectly visible when further layers are applied.

The Airbrush Explosion of the 1960s

The 1960s saw a break with tradition and a stylistic and creative innovation. Music became the main means of expression for the masses, and along with that, music magazines, posters, record album covers, book covers, and so forth, fostered a broad-based development of airbrush technique. The two artistic trends that best expressed and synthesized the current ideas were pop art and superrealism, and the use of the airbrush was basic to both of them.

Pop art took its inspiration from the communications media and the commercial images generated by advertising. The airbrush was used in integrated advertising images, and in retouching photographs its presence was so discreet, nearly undetectable, so that the change was scarcely visible, so publicists recognized the possibility of perfecting the image of their product and falsifying it to make it more attractive. Other artists used the airbrush exclusively to create images, without reference to photography. If art is a reflection of society, pop art was founded in an impersonal and productive society, and its esthetic was a medium that matched its needs. It was an ingenious and festive art, in harmony with the times, and its creators liked the impersonal character of the airbrush, for they weren't searching for individuality, but simply an attractive product, a polished and perfect image that attracted people's attention, in which the artist's hand was to leave no trace of personality. The airbrush is the perfect tool for idealizing everyday objects in the service of advertising, but its application requires creativity.

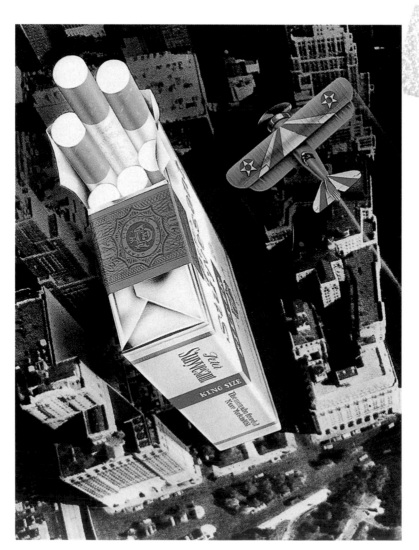

THE HEIGHT OF ADVERTISING
The social revolution that took place in the 1960s throughout the world increased the possibilities for graphic techniques and made art known in a general way and for everyone.

Skyscraper Pack *by Dick Ward. Pop art created unreal images based on commercial products to emphasize their esthetic qualities. Pop sought to sell product by highlighting their visual aspects. The idea of comparing a pack of cigarettes to a huge skyscraper is representative of the philosophy of pop art.*

The Perfection
of the Airbrush

Pop art shared center stage with hyperrealism, but whereas the former developed in all aspects of the culture, the latter was only evident in the field of drawing and painting. This style, which was based on the imitation of photographic images, has lasted to our time, resisting even the most abstract and minimalist tendencies, and its creations are astonishing in their detail and precision.

As with pop art, hyperrealism is akin to photography, but the techniques used and the context in which the works are exhibited require a new perspective on the part of the observer. The paintings tend to be of large format, and the subjects are extremely varied, from landscapes to indoor scenes, portraits, and more. The airbrush is the best ally in creating all the textures that nature can offer; it has as many expressive possibilities as a conventional artist's brush. The painter's creativity and personality are expressed through the development and the results of the work, and are not merely a medium.

Glassware (1978) by Don Eddy. Acrylic on canvas. Here the artist searches for absolute fidelity to reality, perfection, and the utmost detail.

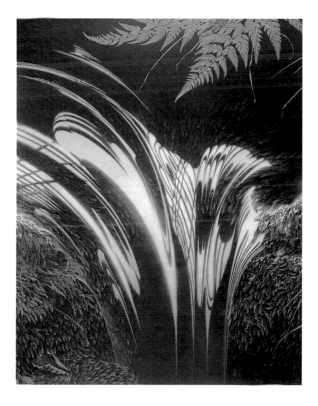

AN ATTRACTIVE INSTRUMENT
After the polemic created by the advent of the airbrush in the world of art, the technique began to gain acceptance, and artists sought new effects and avenues of expression with it. Finally its revolutionary character, which made it possible to address all kinds of subjects, gained recognition. The perfection in the results is surely the main attraction of this technique, which dazzles the observer with its ability to create photographic realism even in the most imaginative subjects.

Stream by Michael English, one of the principal and most innovative airbrush artists of the 1960s. This artist was closely connected to pop art at the beginning, but he developed his work and eventually achieved maximum perfection. In his free works, like this one, he found inspiration in natural features such as water and vegetation. The tiny leaves and the darkness of the surroundings were created by combining spray paint with brushwork for the details. The sheen of the water was done last, using new masks and straight white.

Modern Airbrush Art

The most consistent and important use for the airbrush is in the field of illustration. It was hard for the airbrush to fit into conventional painting, but in the field of illustration it was a real discovery and an advantage. Unfortunately, illustrations don't have the same prestige as great paintings, but they are so accustomed in our daily life that they require absolute professionalism on the part of the artist.

The ability to idealize images and create fantasy with the airbrush is a result of the surrealist movement, which combined reality and dreams. Thus, the airbrush made possible the birth of a post-surrealist movement that included fantastic art and science fiction, which are perfect for airbrush art. This interest in fantastic, futuristic worlds arose in many spheres of culture; the new millennium was approaching, and movies, advertising, and television were filled with images of space ships, robots, and alien creatures. People were looking for a new reality linked to the future to bring the common people closer to new discoveries and the possibilities of new technologies. The future, space travel, the construction of artificial satellites, and a vision of other planets and galaxies all became idealized. This created an obsession with the future and a need on the part of graphic artists to make tangible and current those worlds that hadn't yet arrived. This precision tool leaves no fingerprints or brush marks, so it offers the possibility of producing images as perfect and pure as reality itself; it allows the artist to create an illusion of reality from those fantastic worlds.

But the subjects for illustration are infinite and the degree of detail depends entirely on the nature of the material. For example, short narrations, children's stories, comics, and others are vehicles of expression that can be illustrated simply, without details and precision. Other areas, however, demand more precise visual information; examples include science and technology.

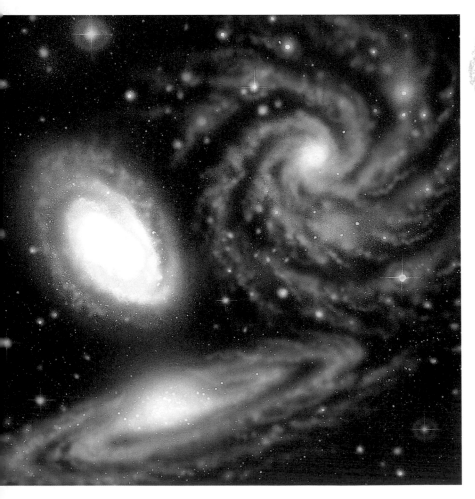

DEPICTING THE INVISIBLE
The representation of natural phenomena was enriched by the arrival of the airbrush, because it can be used to explain features that photography can't capture.

The perfection and wispy nature of airbrush art make it possible to create images of great visual impact, like the ones in this illustration of the galaxies. The light and dark colors blend to give shape to the different types of galaxies, elliptical and spiral. The shades mix without limitations or separations, and all the shapes are unified and created freehand.

Scientific Illustration

There are many branches of science—geology, astronomy, ecology, zoology, botany, medicine, and others. In the study texts of each branch, illustrations are very detailed and even idealized to clarify the information to the maximum degree. In most cases, a photograph can't capture that degree of realism, nor does it allow manipulating the image to make it easier to understand. Another advantage that illustration has over photography is that it can convey features that are invisible to the naked eye, such as atoms, molecules, and cells, plus planets, solar systems, and galaxies. In all these cases, the information is often very theoretical, and photographs, no matter how precise, even with the aid of microscopes and telescopes, can't achieve the same degree of abstraction, exactness, and realism that is possible in an image created with an airbrush.

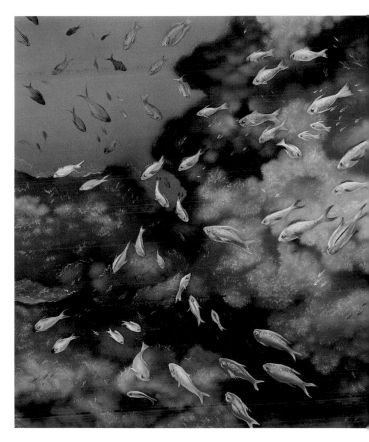

This illustration shows the spectacular colors of a coral reef and the variety of fishes that live in the habitat. The colors applied with an airbrush have great purity, and the images in bright, striking colors are perfect for working in this technique.

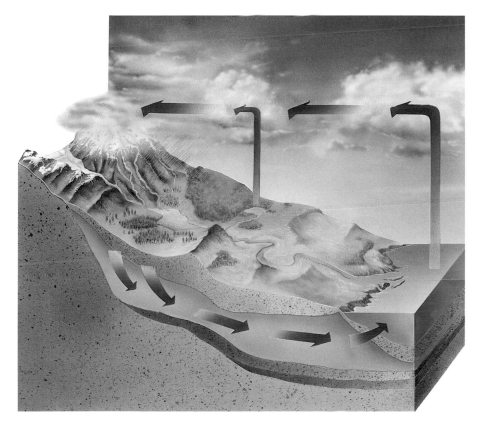

This illustration shows the water cycle: how it evaporates to form clouds, how they condense on the mountains in the form of rain that runs into the river and from there to the ocean, where the water once again evaporates. This is the type of image that explains a natural phenomenon. The documentation, along with the illustrator's imagination, has to be capable of creating a clear, instructive image for an abstract concept like the water cycle.

Technical Illustration

In technical illustrations, the airbrush produces clear images that facilitate comprehension of the subject at hand. In every design project, in addition to the specific views in which the measurements are provided, a final representation in perspective is also included that presents the item in a realistic and detailed form. The airbrush makes it possible to perfectly reproduce the plastic and metal textures and their characteristic gleams and reflections.

The airbrush is also a wonderful tool for depicting sections of technologically complex devices in explanations of their inner workings. These are technical images that require total mastery of realistic drawing and the different representation systems, to scale and in perspective. In addition, the artist needs a rigorous attitude in carrying out the project, plus talent in graphics to determine the best way to present the piece. This last point involves a clearer artistic component, for the ability to express something in a beautiful and appealing way requires creative sensitivity.

Similarly, technical illustrations have to jibe closely with the technical documentation, and although the end result has to be attractive, the precision and fidelity to the model have to come first. This implies exhaustive documentation, and if necessary, the opinion of an expert.

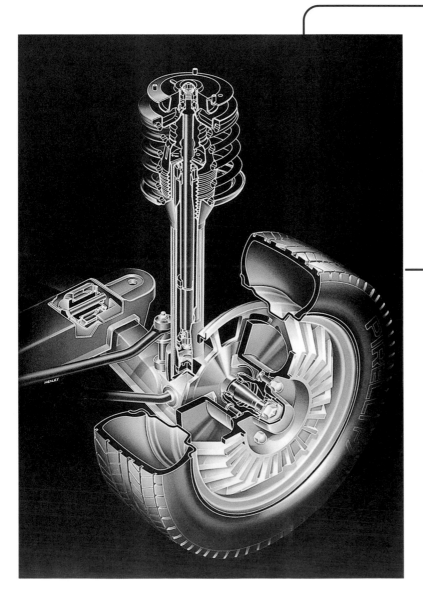

THE USEFULNESS OF ILLUSTRATION
Technical illustrations are extremely useful, both for the commercial promotion of a product and in helping people understand its complexity. Therefore, a familiarity with the material is essential, along with a faithful representation of the model so that the structure of the objects is accurate.

Technical illustration requires slow, meticulous work because of the multitude of details and tiny features that go into an object of this type. In technical illustration, cross-sections are frequently used in showing the parts and the inner functioning of the components. In this case, the cross-section shows the different mechanisms that comprise an automobile wheel.

Instruments and Materials

Airbrush is a complex technique in which all types of materials are used. In the following pages, we will explain all the materials that are needed for doing this type of illustration.

Like any other pictorial technique, airbrush art involves creating images on a surface. However, airbrush is fundamentally different from the other techniques because it involves spraying the surface with paint from a distance, and that requires a mechanical tool—the airbrush—which is a good deal harder to understand and master than other pictorial techniques. The basic principle of the airbrush involves mixing the paints with air and transferring them under pressure to the paper. This is a complex technique because, as we will see throughout these pages, it encompasses many other techniques and involves a very unconventional way of working.

◆

The paint is sprayed with the aid of various accessory materials that help create a perfect image.

◆

Thus, it's important to master not only the materials used, but also the airbrush, and even the device that supplies the air pressure—the reliability of which largely determines the final results.

The principal materials required for doing an airbrush work are the paint—which comes in various types, depending on quality and the intended surface—and the shields and masks that are needed for keeping the spray precise.

Further accessories such as erasers, colored pencils, markers, and various paints, help in outlining and defining the images and producing a striking visual result.

Masks, colored pencils, and thick paints are also used in airbrush art. The artist needs the right materials to be able to work with confidence.

Airbrush Components

Most airbrushes are about the same mechanically, regardless of where the reservoir is located. The main characteristic of this tool is that it dispenses a mixture of paint and air, and some models have a mechanism that allows the artist to control the amount of paint and the pressure under which it exits the tool.

Generally speaking, the most common airbrushes on the market are independent double action—that is, the painter can regulate both the air pressure coming into the tool and the outflow of paint.

The various models of airbrush have a very similar mechanism. The design of the parts may vary, but not the way they work. Airbrushes all have a metallic body into which all the pieces fit and inside which the air and the paint mix.

Independent double action airbrush with a .012" (.3 mm) orifice and a gravity-feed reservoir with a paint capacity of 2.75 cu. in. (7 cm³).

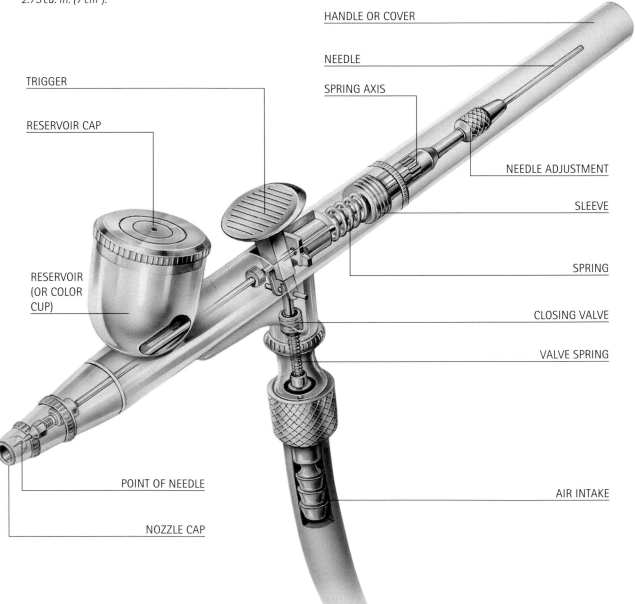

HANDLE OR COVER

NEEDLE

SPRING AXIS

TRIGGER

RESERVOIR CAP

NEEDLE ADJUSTMENT

SLEEVE

SPRING

RESERVOIR (OR COLOR CUP)

CLOSING VALVE

VALVE SPRING

POINT OF NEEDLE

AIR INTAKE

NOZZLE CAP

The paint cup can be located at the top of the airbrush, in which case the paint feeds perfectly well through gravity, or underneath it, requiring suction.

One of the main features of the airbrush is a needle that fits into the nozzle and retracts to allow the paint to flow. This needle must remain in alignment—or otherwise it will obstruct the nozzle and interfere with the ink flow; a part on the inside, the sleeve, keeps it straight. The handle, the outer part that screws directly onto the body of the airbrush, protects the needle and keeps it from breaking or bending.

The valve is in the area where the air hose from the main air supply connects. The valve allows the air into the body of the airbrush.

The activating lever or trigger controls the functioning of the airbrush. This part is connected to two springs that regulate the passage of paint and air. Downward pressure on the lever opens the air valve and controls the airflow; positioning the trigger toward the rear retracts the needle and allows the paint to spray out.

The paint exits smoothly through the orifice. If the orifice becomes distorted, the spray may not be uniform, and it may cause splattering.

The trigger is one of the most important parts of the airbrush, since it controls the lines, the air pressure, and the breadth of the spray. It must be pressed gently, because otherwise it could easily be damaged, given that it is in continuous motion.

There are two types of reservoir on the market: suction (A) and gravity (B). Both types can involve various designs with differences in capacity and height. Gravity reservoirs usually are soldered to the body and have a hole in the bottom for the paint to pass into the body and mix with the air. Suction reservoirs are threaded to the body, so they can be changed for using different colors. They have a cover with a tube that couples to the body of the airbrush and sucks up the paint.

The position of the needle is controlled by a screw that only allows it to move rearward under pressure from the trigger. Before using the airbrush, be sure the chuck nut is installed properly, or else the needle won't retract.

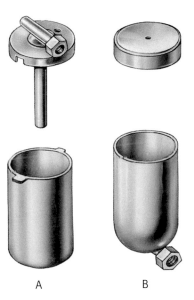

A B

Types of Airbrush

Although all airbrushes are based on the principle of mixing air and paint in accordance with Bernoulli's law, there are various models on the market that have basic differences in the way they work. Thus, there are suction- and gravity-feed airbrushes that use external and internal mixing, and single-action, fixed double-action, and independent double-action airbrushes, depending on how the trigger that controls and regulates the quantities of air and paint is used.

External Atomizing

Atomizing is the mixing of air with the paint—the most common system is internal atomization. However, there are airbrushes, including some very simple ones, that are based on the same system as a simple mouth atomizer; in other words, they use external mixing. Most paint sprayers fall into this category; these are usually fairly imprecise tools that allow working large surfaces that don't require any detailing. Their use is limited to filling in backgrounds or to industrial processes in which mass-produced items are spray-painted and no high degree of definition is needed. Some paint sprayers have a needle that allows a certain amount of control over the paint, depending on how far it is retracted by hand.

This group also includes the sophisticated Paasche AB Turbo airbrush, which is as complex as the independent double-action ones, but which uses external mixing.

THE BERNOULLI PRINCIPLE

All airbrushes are based on the Bernoulli principle, according to which the air that passes through the tube is at a higher pressure than the medium, so the paint climbs through the vertical tube and becomes mixed with the air to form a generous and uniform spray. Mouth atomizers are perfect illustrations of this principle. With airbrushes that use internal atomizing, the air and paint mix in the middle of the right angle.

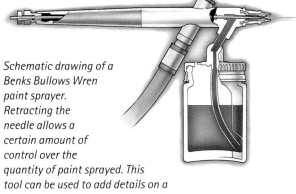

Schematic drawing of a Benks Bullows Wren paint sprayer. Retracting the needle allows a certain amount of control over the quantity of paint sprayed. This tool can be used to add details on a large-format work. It's not a good choice, however, for small illustrations that require greater precision.

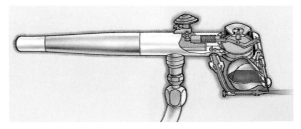

Schematic drawing of a Badger 250 paint sprayer, which has a very basic atomizing mechanism. It is activated by means of a lever that, when pushed, allows the air to flow and mix with the paint. It's a good choice for painting layouts and all kinds of three-dimensional elements, as well as for filling in backgrounds.

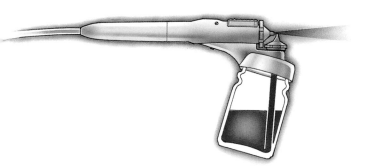

Schematic drawing of a Paasche AB Turbo airbrush. This is the most sophisticated of the airbrushes, and also one of the most difficult ones to use since the mixing takes place externally. Inside there is a high-speed turbine that imparts an oscillating movement to the needle; that way, it picks up the paint that feeds by gravity from the reservoir and atomizes it with the air that's expelled through the nozzle.

Single-action Airbrushes

Single-action airbrushes are characterized by the fact that the trigger merely opens the air outlet valve, and the jet of paint is invariable. The air mixes with the paint either inside or outside the airbrush, depending on its construction. Most paint sprayers are single-action, as are some internal-atomizing airbrushes, such as the Badger Zoo, but they are extremely simple to use.

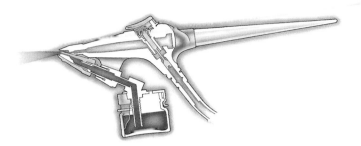

Schematic drawing of a Badger Zoo airbrush; it's a single-action tool with an interchangeable glass reservoir. Line control is quite basic and is regulated along with the airflow. The lower the pressure and the closer the airbrush is to the paper, the finer the line.

Fixed Double-action Airbrushes

In fixed double-action airbrushes the quantity of paint can be controlled by the retraction of the needle by means of the trigger, but the airflow is always the same. When the trigger is pressed rearward, it acts on the mounting for the needle, and the airflow opens.

Even though the air pressure is invariable, this is a professional-quality airbrush. It can be used to produce both fine lines and broader sprays, so it works as well as independent double-action airbrushes.

The German company Efbe is one of the main manufacturers of this type of airbrush. It produces high-quality, precise instruments.

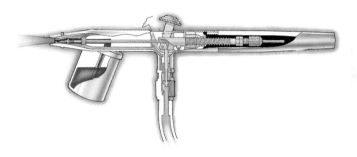

Schematic drawing of the Efbe Hobbyist Model C-1 Airbrush. The trigger can be moved only forward and back, but it can be used for all types of lines and breadths of spray.

Independent Double-action Airbrushes

Independent double-action airbrushes are surely among the most efficient, since the trigger controls the quantity of both the air and the paint. If the trigger is moved rearward, the needle retracts and gradually allows the paint to flow through; if the trigger is moved downward, it regulates the airflow. This tool makes possible all the combinations necessary for doing any type of line and spray, and it's the perfect instrument for any artist's self-expression.

This type of airbrush can work by suction or gravity, and by internal or external mixing, like the Paasche. The great number of combinations and adjustments that can be made with the trigger make these airbrushes the most versatile ones on the market, and most illustrators choose this option for their work.

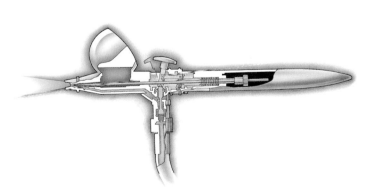

Schematic drawing of a De Vilviss Super 63 airbrush. The trigger is double-action in all airbrushes made like this one. However, since the most important factor in the line is the paint flow, the illustrator can maintain a fixed air pressure and manipulate the opening of the needle valve.

Principal Airbrush Models

Airbrushes have not changed much since their invention, even though the designs have been modernized. The main brands of airbrushes have been manufactured for decades, and several models are available. Professional artists can choose the ones that best meet their needs, always keeping in mind that the independent double-action airbrushes are the most precise and versatile. Let's take a look at some of the common models on the market and their characteristics.

NEW DESIGNS
The new airbrush designs incorporate the latest advances in technology and are adapted to the illustrators' needs. The Fisher Aerostat has an improved trigger that opens the airflow, so now the control over the flow of paint and air is much more precise, and better than with any other model. In addition, it comes with five interchangeable orifices, including one that measures .0039″ (0.1 mm), making it one of the most complete airbrushes on the market.

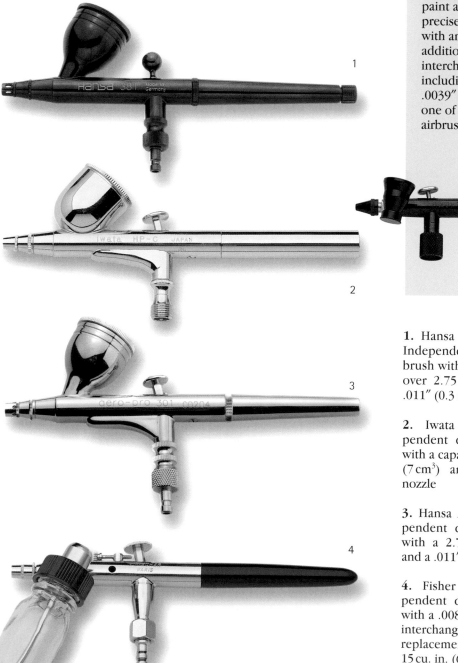

1. Hansa Model 381 black-line. Independent double action airbrush with a color cup that holds over 2.75 cu. in. (7 cm³) and a .011″ (0.3 mm) nozzle

2. Iwata Model HP-C; independent double-action airbrush with a capacity of over 2.75 cu. in. (7 cm³) and a .011″ (0.3 mm) nozzle

3. Hansa Aero-pro model; independent double-action airbrush with a 2.75 cu. in. (7 cm³) cup and a .011″ (0.3 mm) nozzle

4. Fisher Model GI-83; independent double-action airbrush with a .008″ (0.2 mm) nozzle and interchangeable suction reservoir; replacements hold 24, 12, and 15 cu. in. (60, 30, and 15 cm³).

5. Badger Model 250; single action with a .008″ (0.2 mm) nozzle

6. DeVilliss Model Super 63E; independent double action airbrush with 4 cu. in. (10 cm^3) cup and a .008″ nozzle

7. Paasche Model AB Turbo; external mixing airbrush with independent double action. The cup capacity is small and the orifice is .008 (0.2 mm). This is a good choice for works of great precision, since the small reservoir is not suited to large sprays.

8. Efbe Model C-1; independent double-action airbrush with suction feed and 2.5 cu. in. (6 cm^3) and a .011″ (0 3 mm) orifice

9. Aztek Model 3000-S by Kodak; a very functional design with four interchangeable nozzles. The cup has a capacity of 2.5 cu. in. (6 cm^3); spare parts are included. The orifice is .011″ (0.3 mm). The main characteristic of this airbrush is that the body is made of rigid plastic and is much lighter than earlier models.

10. Chameleon independent double-action airbrush with a reservoir for eight colors that can be mixed together and an additional reservoir for cleaning solvent. This model is also sold without the reservoir and serves the same purposes as the models described earlier.

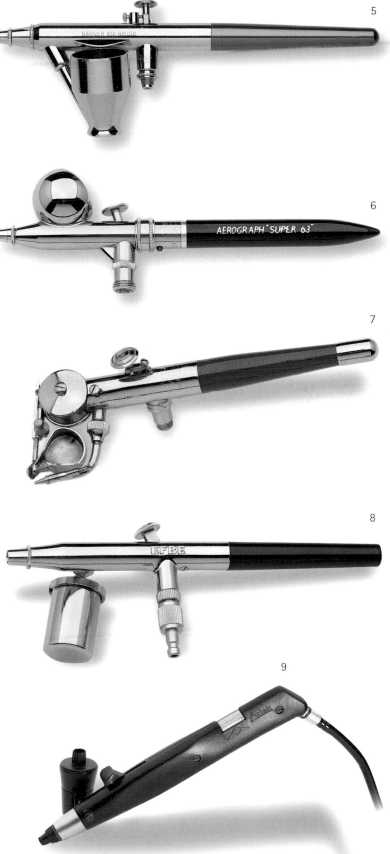

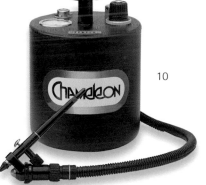

Air Supply

As we have already mentioned, the airbrush always involves an air supply, without which the spray is not possible. Air supply systems have varied a lot since this tool was invented; today, modern compressors are small and quiet, and they are the best option for continuous, professional work. Next we will describe the systems that are available in the marketplace, from the simplest and most economical to the most complex.

AIR, A NECESSARY INGREDIENT
The spray is a combination of air and paint; the air is thus an essential ingredient that can be provided by means ranging from a blowpipe to reservoirs and compressors.

Cans of Compressed Air

Cans of compressed air are small and are easy to transport anywhere; their exterior shape is similar to aerosols, but they have a valve on top that attaches to the airbrush. As a result, since there is a direct connection, no type of hose is required.

These cans contain air that is released when the airbrush's trigger is depressed, since it simultaneously pushes down on the release valve on the can. This is a fairly new product, and it's inexpensive and perfectly acceptable for getting started in airbrush technique. Its main drawback is its low capacity, which can't support very long sessions. Keep in mind that pressure decreases as the contents are used up, and that can cause interruptions in the work and compromise the quality of the spray.

Canisters of Compressed Air

CO_2 canisters were the main system for supplying air to the airbrush for many years, especially in the early stages of the technique. These are very silent and freestanding sources that don't need to be hooked up to electricity. The airflow is continuous, without fluctuation, and it can be regulated with a manometer. At first, the air supply would give out suddenly, with no warning; but later on, gauges were added that continually displayed the contents of the container.

The canisters were refillable, but they had to be brought to a special business place. Currently, such canisters are an alternative to compressors, even though the compressors have totally taken over, and they are not the best choice for professional use.

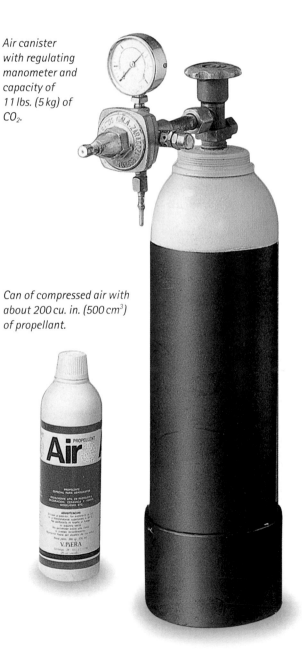

Air canister with regulating manometer and capacity of 11 lbs. (5 kg) of CO_2.

Can of compressed air with about 200 cu. in. (500 cm³) of propellant.

Aerosol Paints

Spray or aerosol paints involve a canister of diluted paint and a gas propellant that atomizes the paint externally when the button on the top is pushed down. These cans work on the Bernoulli principle, like all airbrushes and paint sprayers.

The gas propellant—CO_2, xylene, toluene, or others—is very volatile and is subjected to pressure in the container that expels the paint when the valve is pressed. The type of paint in these aerosols is enamel; it dissolves in acetone and special solvents. The hardness of these paints assures a brilliant and durable finish, since they are very resistant to all kinds of external factors, especially the weather; that's why aerosols are used for the graffiti that cover many walls of our cities.

Example of street graffiti that show the abilities of aerosol paints to handle lines and large areas, as a function of how far the can is held from the surface. Up close, the effect is more linear and detailed; from farther away, though, the spray can fill a large area in the same was as a conventional airbrush.

Aerosol paints can be bought in any paint or art store. They are inexpensive, and they are available in a broad spectrum of shades, including very artificial ones such as chromes and fluorescent colors. The output nozzle is fairly coarse, which makes these paints very useful in large formats, but not for small works, because you can't trace fine lines. To produce the right color intensity, it's recommended to work at a distance of eight to twelve inches (20–30 cm) from the surface.

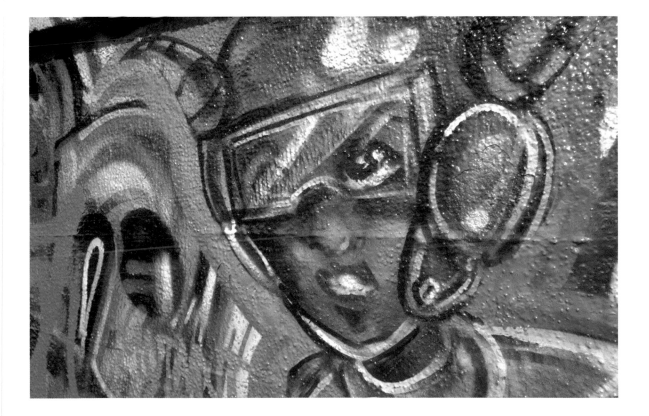

Airbrush Paints

The orifices in airbrushes are usually very small, from around .008" to .011" (0.2–0.3 mm); so the paints that are used for the spray have to be fluid enough so that they flow normally without obstructing the passageway. Most liquid watercolors and acrylic paints have that characteristic; however, there are paints that have to be thinned to create the optimal degree of fluidity. With regard to colors, any of the existing types offers a very broad range. The colors may be opaque or transparent; the former are denser, since they are capable of covering other dark colors.

Liquid watercolors and totally liquid anilines with great coloring capacity due to the purity of the pigments.

Watercolors and Anilines

Watercolors are perfectly suited to airbrush work. Watercolors made specifically for airbrushes look very different from the ones in cups or tubes, and they are a fine choice for beginners. They are economical and they don't clog up the airbrush, since the pigment is completely dissolved. These liquid watercolors come in small jars or larger bottles in a wide range of colors. The quality of the pigments is assured, as is the strength, the purity, and the brightness of the colors. If so desired, they can even be diluted with water to produce a softer shade. Blotching rarely occurs with liquid watercolors, since the thinner the paint, the finer the atomizing, and the easier it is to keep the tool clean.

Anilines are liquid inks, pigmented solutions with synthetic colors, which are soluble in water or alcohol. They are frequently used in the field of design and illustration, and they may be either matte or glossy. They produce excellent results when applied in layers of a single color, for the colors are very strong and permanent.

The difference between liquid watercolors and anilines is how they behave in mixtures. The latter have too much pigmentation to create the tremendous variety and exquisite shades that become possible by mixing liquid watercolors.

After using both types of color, it's a good idea to give the airbrush a simple cleaning with water, since water never clogs, and follow that with alcohol.

Liquid paints are ideal for airbrush work.

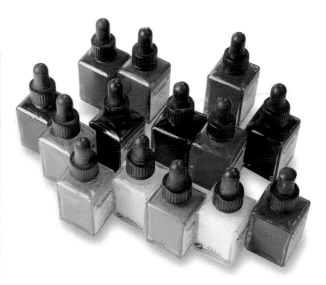

Every manufacturer has its own way of packaging acrylic paints. It's a good idea to use the brands that have a dropper built into the cap, since that makes it much easier to mix colors.

Acrylic Paints

Acrylic paints are the best choice for professional use, since the sprays remain constant once they dry. These paints are the product of long research to find an ideal product for airbrush art, so they are a fairly recent invention. These are non-toxic acrylic solutions with a high concentration of very fine pigments that won't clog up the airbrush.

Acrylics have several advantages over liquid watercolors. First of all, they dry more quickly, so the paper doesn't buckle, which sometimes occurs with watercolors—especially if a significant amount is applied. Another advantage, as we have already indicated, is that acrylics are permanent once they dry, and even if they come in contact with water, they remain unchanged, since they form a protective film. With watercolors, the color may get washed out. Acrylics are commonly dissolved in a little water before use, since the color is very concentrated. They usually have some sediment at the bottom, so the container should be shaken thoroughly before use. Still, not all acrylics exhibit the same density.

Acrylics can be either opaque or transparent. The bright colors are very liquid and transparent, and they behave much like liquid watercolors. The earthy colors are a little denser; the pigment tends to be less intense than the pure colors, so more is needed, and that's why they are made in denser consistencies. White is the most dense and opaque color in the spectrum; it's also the hardest one to clean from inside the airbrush.

Opaque colors such as white tend to be denser than the others. They require very careful cleaning after use, since they may clog the nozzle for subsequent use.

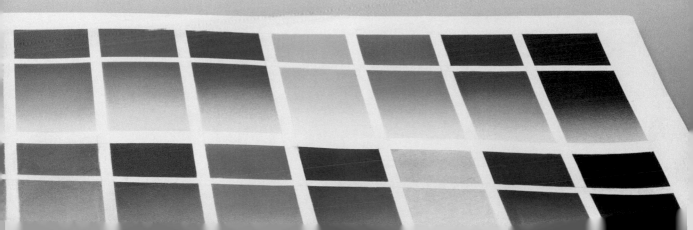

Special Paints

The airbrush is an appropriate tool for all types of paints as long as a sufficiently strong solvent and cleaner are used to remove all traces. Oils and enamels are frequently used both for painting canvasses and working on models and all types of objects—dolls, for example—and even makeup and creating special effects on characters in fantasy films. In such cases, the airbrush is not merely a tool for illustration, but also for expressiveness in handcrafted items.

The airbrush is a very important tool in creating models and all kinds of characters designed for movies and television. One good example is the decoration of theater puppets involving caricatures of known personages to create a comical image of the subject.

Oils

For airbrush art, oils need to be thinned significantly with refined essence of turpentine and a few drops of drier to speed up the drying process. Oils can be used for painting canvases, wood, and even ceramics and glass, and they produce fine, precise shading. The only substrate that's not recommended for oils is paper, since it may be damaged and smudged by the varnishes and solvents.

Most oil colors are opaque, although some of them are fairly transparent when properly diluted. These colors are listed in some catalogs as lacquers; they can be used to produce velaturas, transparencies, and other effects appropriate to liquid paints.

Oil paints in tubes. Essence of turpentine is needed for creating the appropriate texture.

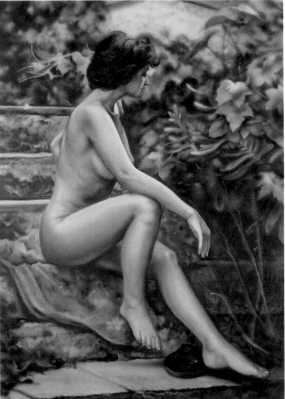

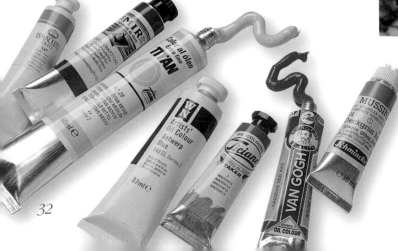

Nude woman. This work was done entirely with oil paints. The airbrush has produced the texture of the model's flesh tones and the shading in the surroundings. The details will be done with an artist's brush. The result is a high-quality image with regard to the surroundings and the finish details.

Paints for Cloth

Paints for cloth have to produce solid colors that resist water and the detergents used for washing, so fixatives are used in the process. These paints are usually water soluble, so before they are put into the airbrush they can be diluted as much as necessary, even though they are quite fluid to begin with. They are easy to mix, and it's possible to create any type of color spectrum with very pure colors. They can usually withstand temperatures up to 140°F (60°C) during washing, including machine wash.

The process of creating a drawing on a T-shirt, for example, is the same as on paper, but once it's finished it's a good idea to wait until it's totally dry and then turn the shirt over and iron it for a few minutes with a very hot iron, since the heat will fix the colors permanently to the cloth.

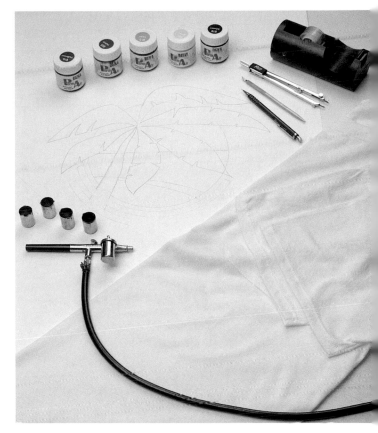

Materials needed for painting a T-shirt. Since these paints tend to be fairly expensive, you can get by with the primary colors plus black to create any mixture.

Cellulose Paints

Cellulose or enamel paints contain lacquers and very strong solvents. They are commonly used for industrial applications and are ideal for painting toys, models, and other plastic and non-porous items. A paint sprayer is the best tool for atomizing enamels. If you use an airbrush, the cleaning process is very complicated, and it has to be done before the paint dries. The solvents used in making enamels are very powerful, as we have already indicated, plus they are flammable and toxic, so it's a good idea to wear a protective mask while spraying. All enamels cover well and dry very quickly, so you need to clean the tools frequently and quickly.

Basic paint sprayers can be used on this type of model, since this involves giving the object an overall color. The details can be done by hand. Enamel is a very dense paint, and it can easily damage an airbrush. With enamels it's always better to use a paint sprayer in which the air and paint mix externally and can't gum up the mechanism.

Opaque and Transparent Colors

The agents responsible for color are the pigment and the agglutinants. Liquid watercolors, anilines, and paints for cloth are essentially transparent, and enamels and oils are opaque because of their dense, thick texture. Acrylic paints, the ones most commonly used in airbrush art, may be either opaque or transparent; both types are made with a very fine pigment to keep the nozzle from clogging, and they produce very neat results.

Transparent colors are worked from lesser to greater intensity in such a way that color saturation is achieved by applying successive layers. When working in transparency, it's hard to correct errors, so it's wise to plan the colors beforehand, just as when painting with watercolors. The task is simplified when everything from the boldest to the subtlest shades can be created with a single pass; this is what's known as a velatura, in which the new color doesn't cover the previous one, but merely modifies it.

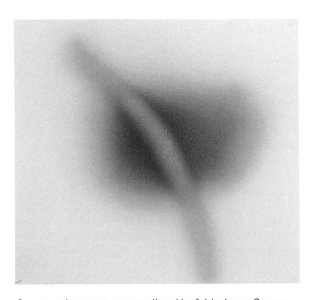

Opaque colors must cover well and be fairly dense. Opaque acrylics are usually identified on the label; it's easy to test their density by shaking the container. They become more transparent with the addition of water; if they are used straight, they are completely opaque. One problem with opaque colors is their slow drying time, since they need more paint to cover an area, and that slows down the masking process.

Opaque colors make it possible to cover a dark surface with a lighter one. This can be done over a color applied with airbrush as well as on a paper that's already colored. The density of the painting will cover perfectly well.

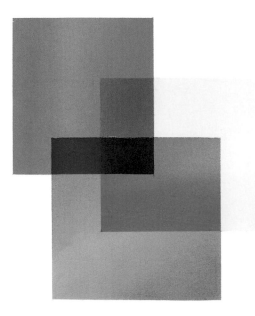

When transparent colors are mixed together they produce new shades, so you can create many hues with a small number of colors. In working with shapes, this is accomplished by fusing colors, but it's more evident in working with flat colors, as with the squares at the left, where new colors are created by superposition.

Supports

The choice of support depends on the type of work the artist wants to do—filling in backgrounds, applying flat colors, or a more minutely detailed work, for example—as well as on the type of paint used. So in doing an illustration that requires a lot of detail and precision, it's preferable to use smooth, untextured papers, whereas for more rudimentary works the substrate can be coarser and rough.

Paper Types

Paper for airbrush art needs to meet certain requirements to produce a good finish with regard to shape and color. A smooth paper with little texture is a good choice to keep the paint from soaking in too much, and with sufficient weight so that it doesn't buckle, especially when working with watercolors. A thick paper is preferable, with a weight over twelve ounces (300 g), as is airbrush board with a surface and finish similar to high-quality paper.

In evaluating the quality of a paper, you merely need to examine it against the light. If the surface is smooth and uniform, the paper is of high quality; if it shows lumps of pulp in certain areas or other inconsistencies, the paper is of lower quality.

The Effects of Grain

The texture of the paper is a deciding factor in the final results of a painting done with an airbrush. For example, illustrations with lots of details and information need to be worked with auxiliary materials, such as pencils or gouaches, and fine lines must be done neatly. In such cases, the best choice is a paper with a satin finish and a grain so fine that it's almost imperceptible, with no unevenness, to assure an impeccable line. In contrast, for more artistic works it's common to seek original effects and various textures that require papers with very different characteristics. Papers with special textures are ideal for more primitive works done by hand or with a brush that won't be painting anything too detailed. Very fine free artistic works such as watercolors can be done with heavily grained papers, or textured papers that imitate the weave of linen. Remember that the paper must always be substantial in weight.

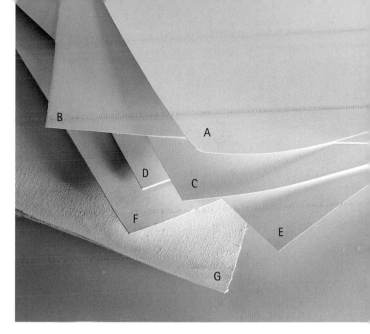

Papers recommended for airbrush: Schoeller Durex with a satin finish (A), Bristol (C), Schoeller illustration board (D), Caballo brand paper (E), Guarro common basic (F), and linen (weight over ten ounces [250 g] to avoid buckling and surprises when cutting masking) (G).

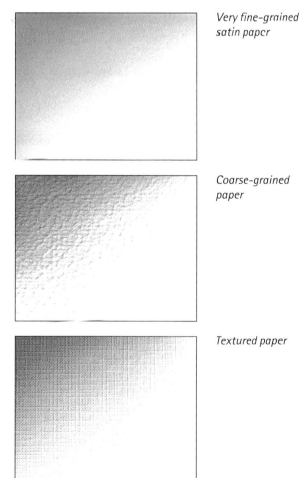

Very fine-grained satin paper

Coarse-grained paper

Textured paper

Special Supports

Canvases on stretchers or cardboard for oils and acrylics are common in creative airbrush art, and their characteristics are the same as with canvases for brushwork. The type of canvas that's best suited to the painter's creative needs can be chosen, as long as the weave is not too highly textured, since the airbrush doesn't allow for creating relief or impastos.

Wood boards and plywood sheets have a smooth surface that's excellent for working with an airbrush. However, one or more layers of primer have to be applied first, and the area has to be sanded very carefully to waterproof it and smooth it out.

Metals and plastics are also great substrates, since they have perfectly clean, smooth surfaces with no imperfections. The most common choices are aluminum, copper, and brass plates, and sheets of acetate, polyvinyl chloride, and methacrylate. Enamel is one of the best paints for adhering to these non-porous materials.

Sometimes the artist works directly on a photograph in the advertising field. Photo paper can be either matte or glossy, and it comes in different thicknesses. The thickest papers are best for large-format works since they generally retain their shape well and even allow scratch techniques for creating special effects. Gouache adheres very well to this type of paper.

Ceramic materials are worked solely with enamels, and subsequently are vitrified by firing in a kiln. The airbrush is also used in restoration work involving objects made with these materials and in cold decorating white china; in these cases, a special cellulose enamel is usually applied that becomes very hard and tough when it dries.

CHOOSING A SUPPORT
The substrate for spraying depends on the paints used; airbrushes and brushes are merely tools, and the paint determines the nature of the substrate.

Different types of supports that are commonly used in airbrush art.

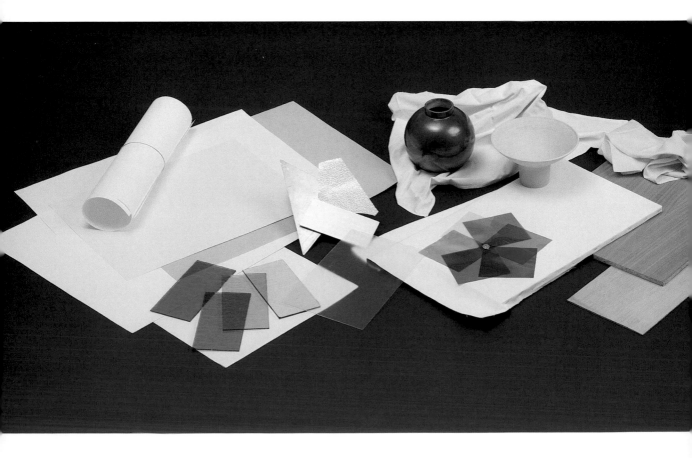

Masking

There are essentially two types of masks, fixed and movable, or shields. Their function is to block out certain areas of the paper and protect them from the paint spray.

Self-adhering Masking

Self-adhering fixed masking (commonly referred to as frisketing) is used when you wish to set aside concrete and very precise shapes; the outline must be cut with a hobby knife. This masking sticks to the substrate the same way as cellophane tape, but with the difference that it can be removed easily from the paper without causing any damage. The frisket film is sold both in individual sheets and in rolls. The former are ideal for very concrete and sporadic work. Rolls (from 30 to 90 feet/10–30 m) are more economical and are a good choice for more professional work carried out over several sessions.

Frisket film keeps the color from getting underneath it, since it has a high power of adhesion. It is also very thin, so it avoids accumulations of paint along the edges and facilitates creating very clear borders. Because it's transparent you can still see the masked area of the illustration, and you can even draw on it.

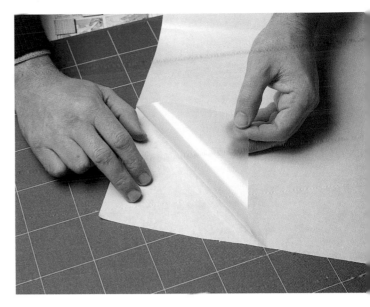

Frisket film has a protective paper that must be removed from the plastic.

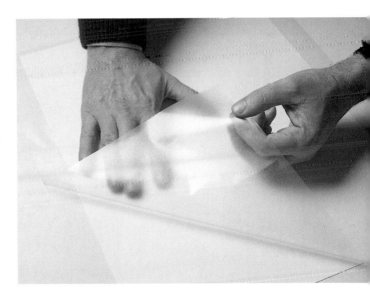

When the masking is applied over the illustration paper, it must always be flattened out with the hand to eliminate air bubbles.

The shape blocked out by the frisket film comes out perfect. The color never gets through the masking.

HOW MASKING WAS DONE IN THE OLD DAYS
Before the advent of frisket film, polyester masking was used; that consisted of transparent paper that was fastened to the substrate with rubber cement. Rubber cement is an effective adhesive that doesn't damage the paper or the paint when it's removed. The work process was the same as with self-adhering masking: attach the paper onto the illustration, cut out the area to be set aside, and apply the color.

In freehand illustrations that don't need much masking, only the margins of the paper are protected. You don't need to use frisket film for that purpose, since all you need is a little masking tape, which is more economical and available in stores everywhere. However, the masking tape shouldn't be too strong, since it could damage the surface of the paper. In general, paper masking tapes produce very good results.

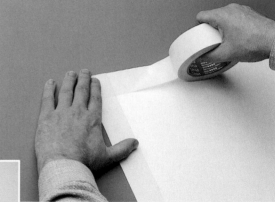

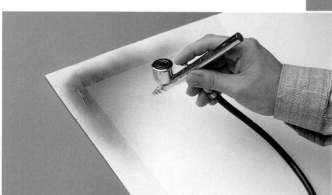

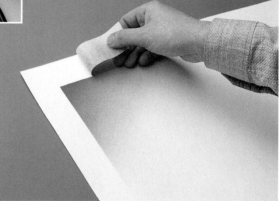

Use masking tape to block out the margins of the paper, making sure that the tape is perfectly straight. Then you can spray the paper with paint without fear of trespassing on the margins. The result is neat, straight borders.

One of the uncertainties that arise in the process of masking an illustration is the order in which the masks should be applied. That depends entirely on whether you begin with the background or the figure. When you want to keep one color from being influenced by the spray of another it should be blocked out; on the other hand, if the new color is similar to the preceding one, or you want to create a velatura, it's not necessary to block off that area.

Take a look at the logical sequence for masking this illustration:

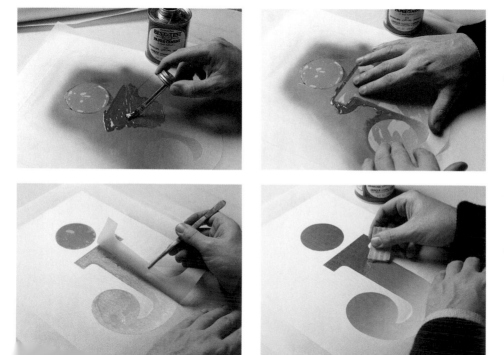

Polyester masking held in place with rubber is still used in working with grained papers. Frisket film can pull the paint off the paper, but the masking that's held in place with rubber has no ill effect on the color. To remove the remains of the rubber cement, wait for them to dry and then remove them with an art gum eraser.

Masking Cutters

Masking can be cut with different tools, depending on the desired shape. For straight lines you can use a hobby knife, and for more complex drawings with many convolutions, a scalpel-type cutter is a good choice—it's easy to use, almost as if it were a pencil. These types of cutters are made of different materials. The best ones are made of ceramic, which doesn't wear out or break. Cutters with a rotary head are ideal for cutting curves, especially tight ones in which a normal knife might not perform well. Replacement blades for cutters of all sizes and shapes are available, except for the ceramic ones, in which the blade is built into the instrument.

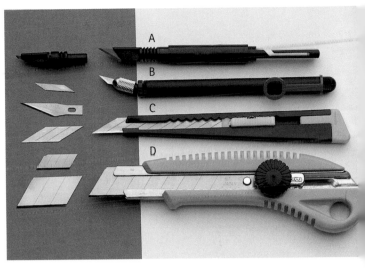

Some of the many types of cutters available on the market: a scalpel-type cutter with a ceramic point and two applicators of different sizes, the smaller of which is for very fine details (A); a rotary-head cutter (B), a cutter for paper or illustration board (C), and a large cutter for cardboard and thick materials (D).

Compass Cutters

Circumference cutters work the same way as conventional compasses, but instead of a pencil lead, they are equipped with a blade. The shape is a little different, since they have a thumbscrew for setting the desired radius and keep it from changing with the pressure exerted on the tool in cutting. The blades for this type of cutter wear out quickly and must be changed often. They have to be in perfect condition, for if you press hard on the compass you can leave a mark in the center of the circle where the point contacted the paper. One way to keep that from happening is to put a small piece of paper in the center for the point to rest on without damaging the substrate.

Note how cleanly the swivel-head cutter handles these curves.

The cutting position is proper when the axis is absolutely perpendicular to the paper. Note the thumbscrew for setting the radius of the circle.

If the blade is sharp enough, you'll need to cut around the figure only once for it to separate easily from the paper.

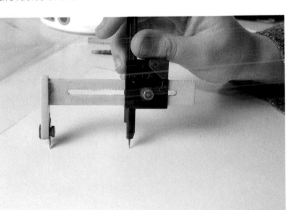

Shields

Shields or movable masks are also used very frequently. They are easier to use than fixed masking. Since they usually are very simple shapes, you can make them yourself or buy them in standard shapes in a specialty shop.

Prefabricated Shields

In stores, there is a broad array of shields and straightedges available for airbrushing curved and straight lines (in the shape of ovals, triangles, radiuses, squares, arrows, numbers, letters, and more). These can be used either as movable shields or for drawing and cutting out silhouettes accurately and confidently.

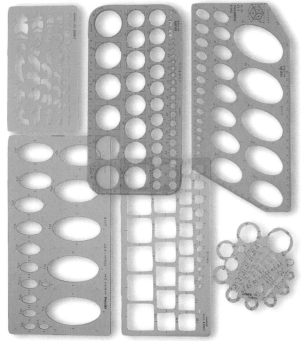

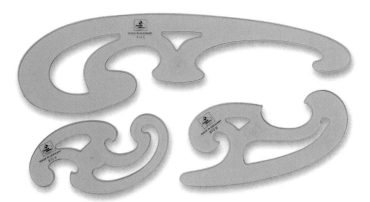

There are many plastic templates available that make it possible to represent any shape without using frisket film.

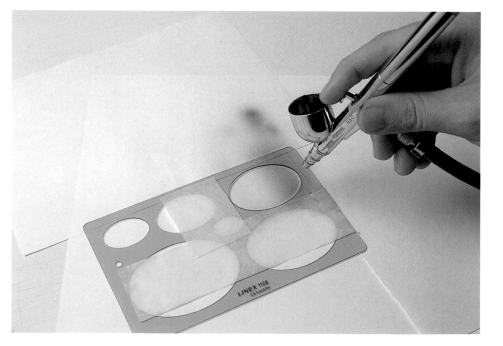

To airbrush over one of the template shapes without reproducing its neighbors, the rest of the cutouts should be covered with frisketing or tape so that the color gets into only the uncovered one.

Paper for Making Templates

Sometimes you don't have to use frisketing to block out an area. When you want to spray a simple shape, you can cut a template out of paper, as if it were a movable shield, and hold it in place with your hand. You can use any type of paper for this, although it's a good idea to use tracing paper, because its transparency will allow you to see the drawing underneath perfectly well.

THE SIMPLEST SHIELDS
Aerial shields are very useful in creating indefinite shapes and backgrounds, and you don't have to use the frisket film that is better suited for specific, precise shapes.

Irregular Shields

To create abstract effects or certain shapes, such as the silhouette of distant mountains or unevenness in the terrain, it's a good idea to use movable shields made of torn paper; in other words, you don't cut the paper cleanly, but tear it randomly with your hands. That way the outlines will be imprecise and irregular. The thicker the paper used for the shield the vaguer the effect of the spray, since the thicker paper doesn't cling as tightly to the substrate and the paint gets underneath it.

Finer paper adheres to the substrate better, so the sprayed outline is fairly clean. Since this template is made of compact paper, it produces a much cleaner cut than with lower-quality papers. Papers that are not very compact form wrinkles and uneven areas that produce a blurry outline when sprayed. Because of the thickness and low quality of cardboard, it produces fairly imprecise outlines.

Example of how the quality of the paper used for the template produces one effect or another.

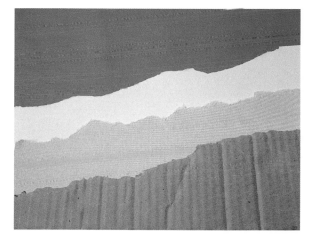

Aerial Shields

Aerial shields are either held a certain distance from the surface or held in place with rubber cement or pieces of masking tape. They don't produce the same precision of outline as the fixed or movable shields. The farther the shield is held from the surface, the greater the imprecision. If you want a fairly well defined outline, the shield can be attached firmly; otherwise the air from the spray gun may move it and produce a strange, undesirable effect.

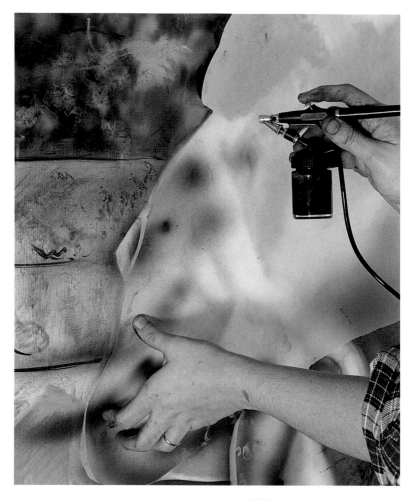

Tracing paper makes it possible to go over any silhouette and block it out, since the transparency of the paper allows cutting out the shapes with as much precision as with frisket film.

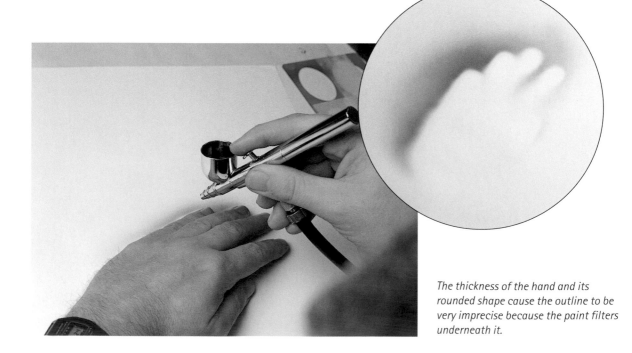

The thickness of the hand and its rounded shape cause the outline to be very imprecise because the paint filters underneath it.

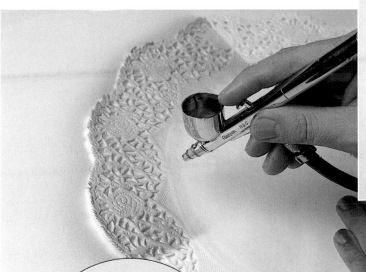

A high degree of precision can be obtained with an aerial shield made of die-cut or fine paper.

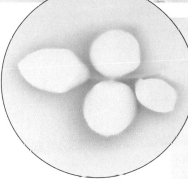

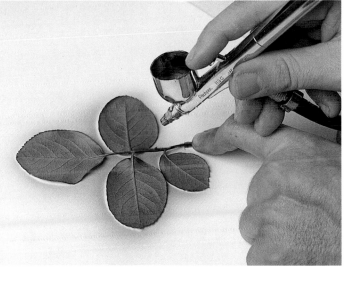

With this aerial shield, it's clear that the outline is much more clearly defined in the flat leaves than the rounded stem, under which paint filtered during the spraying.

Cotton may be the most typical aerial shield. Its lightness and fragility make it move continually when the air is applied, which produces gentle shading that is often used in creating wispy skies.

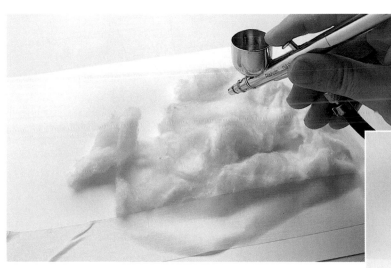

Touch-up Materials

In the field of illustrating other procedures besides airbrush are used for final finishes, outlining, and the last details. The airbrush is an implement for quickly filling in large and medium-size backgrounds; it permits a process of progressive detailing only up to a certain point. For the final strokes, other resources and materials are very useful. We'll now take a look at a few examples.

Colored Pencils

These are commonly used resources in doing details and linear shapes that wouldn't be sharp enough with the airbrush even if it were held very close to the paper. Colored pencils can also be used almost imperceptibly with sprayed paint, since they allow subtle shading and blending. In doing fine lines, the point must be very sharp to create greater precision than with the airbrush. Also, pencils can serve to establish a more finished basic drawing than with a stick of graphite; then the spraying blends in with the color and becomes part of it.

Pencils must be of good quality. If they are used for drawing lines, they don't have to be watercolor pencils; however, if they are to be sprayed over, it's better to use that type of pencil so that the lines blend in with the liquid paint.

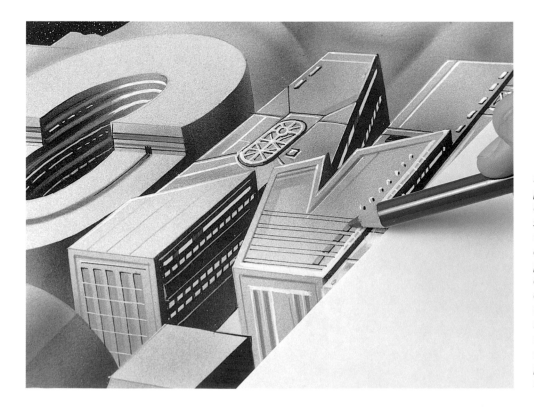

In this case, pencils have been used for the specific lines that would be very difficult to produce with an airbrush. This is one way to save time and effort; in addition, the texture of the pencil is practically imperceptible.

Markers

Markers are used much like colored pencils, but they are reserved solely for concrete shapes, and never for shading, for the strokes would be visible. One advantage they have over pencils is their powerful coloring, since with a single stroke you can create a very intense shade on any kind of detail.

THE SIZE OF THE MARKER

Markers are commonly used at the end of a project in order to define and establish specific details and linear forms. Logically, the size of the marker has a major influence on the final result in the work; the most commonly used markers, which have fine or medium points, usually help in creating definition in very imprecise areas where the sprayed paint is not sufficiently clear. Broad color areas done with thick markers don't fit in well with the wispy effects of the airbrush.

Markers must always be used last, for once they are applied there is no possibility of erasing or disguising the line. So you have to plan very carefully and use the markers at the right time. Also, it's helpful to have a good selection of colors in medium and fine points; broad-tipped markers are not a good choice.

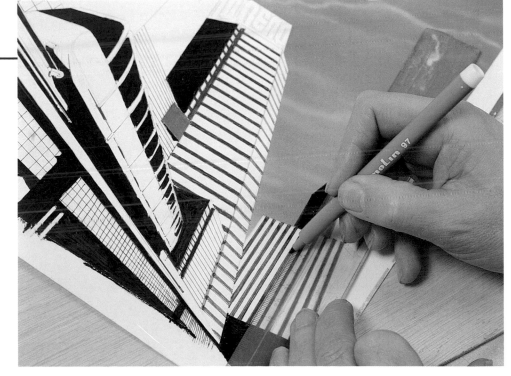

In this drawing, the defining lines of the buildings are being applied with clear, sharp strokes, using blue as well as black in the darkest areas, with the aid of a ruler and a medium-point marker.

One of the main advantages that gouaches have over markers and pencils is that they can be mixed to create new colors.

Gouache

Gouache, like the other accessory materials, helps with the final finish of the illustration. It's helpful to have a good selection of brushes, especially fine-tipped ones, for proper application of lines as precise as with markers and colored pencils. Gouaches can cover any color, unlike markers, which can be applied only dark over light. However, you have to keep in mind that all details done by brush require a steadier hand than with other instruments.

It's always a good idea to use high-quality gouaches that cover well and make clean lines without letting the color underneath show through. Gouaches come in tubes or tablets, and they can be applied with an airbrush once they are dissolved. In that case, the tool will need a thorough cleaning.

The lightest shades, especially white, can be achieved only with gouaches, which allow the purest reflections to stand out against the background.

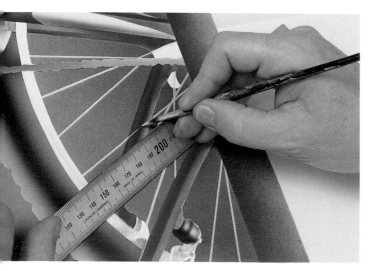

Rubber Erasers

A surface can be lightened only by using an eraser or by spraying with white. Erasers are very commonly used in airbrush art for correcting errors, erasing lines, and especially, creating lighter shades when a color turns out too dark. An eraser is effective only on transparent colors. Opaque colors can be lightened only by spraying with white. Erasers, like the airbrush, can be used to create everything from subtle lightening to pure white. There are several types of eraser available.

Common rubber eraser. It should be fairly hard so it will lighten the color appropriately.

An erasing pencil with a wood shaft that can be sharpened as it is used, and a refillable erasing pencil, which usually has a softer rubber.

An electric eraser. In use the eraser on the tip spins quickly and lightens the paint aggressively. The erasers can be changed with harder ones for erasing darker paints.

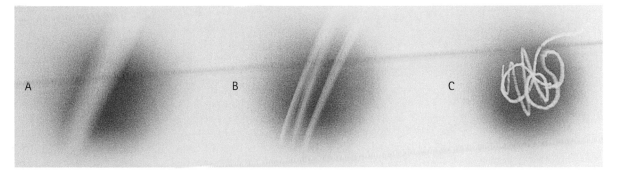

A B C

Note the effect of the various erasers on a patch of color: with a common eraser you can produce a significant gradation (A).
The erasures become more clear with a refillable erasing pencil (B).
The electric eraser produces a clear line that perfectly restores the white of the paper by eliminating all traces of the paint (C).

Blocking with Glue Paint

Glue paint or liquid masking is a substance that adheres to the paper after being applied with a brush. It's made of rubber (which gives it adhesion) and ammonia. It's liquid in texture, but with time it thickens; when that happens, it's a good idea to add a few drops of ammonia and shake the bottle vigorously until the original liquidity is restored. The color is yellowish or grayish, never transparent, so that the painter can clearly make out the shapes drawn with it. In applying liquid masking, it works well to use synthetic-bristle brushes, since the product is very corrosive and may damage natural bristles. Brushes should be cleaned with solvent after use.

Glue paint is used for blocking out small shapes and outlines. In this case, the eraser is used to outline the entire sign and define the shapes clearly. Next, it is sprayed with paint and allowed to dry. After the liquid masking is removed we can see how perfect the results are.

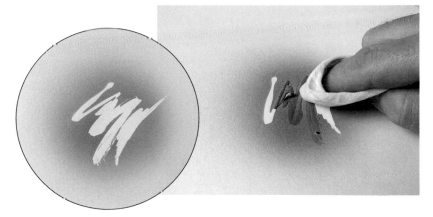

To remove the masking, wait until the spray is perfectly dry, especially on the glue paint, where it takes a little longer. The masking is removed with a rag or an art gum eraser. The outlines are defined perfectly by the lines done with the brush.

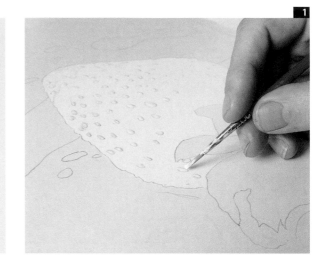

CONSERVING GLUE PAINT
Liquid masking always contains some pigment to provide a little color, which is always yellowish or grayish, never transparent, since the painter needs to be able to make out the lines done with the masking. Regarding the brushes used for applying the masking, the best choices are ones with synthetic bristles, since liquid rubber is an aggressive product that can damage natural bristles. After use, the brush should be cleaned with solvent, which is the only way to remove all the masking.

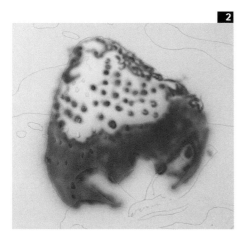

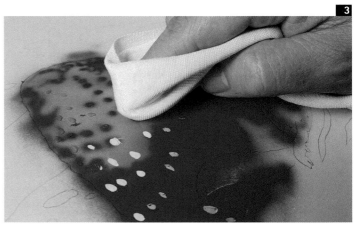

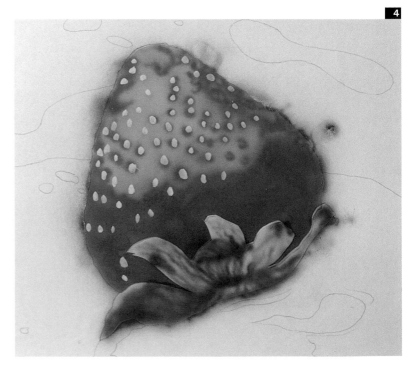

1 From a practical standpoint, glue paint is used for covering small sections of a drawing, such as the seeds of this strawberry.

2 The masked areas are surrounded with small patches of red to indicate the furrows in which the seeds are located.

3 Once the paint is dry, the rubber is removed by rubbing gently with a rag.

4 When the rubber is uncovered, the color is shaded off by adding a yellowish ochre that matches the color of the seeds.

First Steps with the Airbrush

The airbrush requires a slow learning process that begins with the easiest shapes such as dots, straight lines, shading, and smooth backgrounds, before tackling more complex illustrations.

As we have already mentioned, using an airbrush is unlike any of the usual pictorial techniques. Since it's a mechanical tool, it requires a little advance technical knowledge that will serve you well later on. The real challenge, however, comes with the first spraying, in direct contact with the tool. It's impossible to complete a marginally acceptable illustration without first doing some basic exercises to acquire dexterity in using the airbrush trigger.

As a new mechanical tool, the airbrush requires a familiarity with its internal construction and the problems that can arise through paint obstructions, air leaks, and so forth. Throughout these pages, we

◆

Your first steps with the airbrush will help you gradually become familiar with the tool.

◆

will try to explain the most common problems associated with continuous use of the apparatus, as well as some solutions. We will also explain the first steps for controlling the trigger, which is essential in all types of stroke whether using broad sprays or creating specific, controlled shapes and colors. In all cases, there are several elements that make it possible to produce all the possibilities of spraying—air pressure, the amount of paint used, and the distance of the airbrush from the paper. By controlling these three factors, you will be able to create all kinds of textures and combinations.

All kinds of attractive effects can be created by using movable shields and a careful preliminary consideration of colors.

How to Activate the Airbrush

An airbrush is a very fragile and sensitive tool, so it can be damaged easily if it's not used properly. It must be held firmly and activated correctly to avoid forcing the trigger and damaging it. Keep in mind that this is the part that is most commonly damaged in an airbrush; as a result, the first thing you have to learn is how to operate it smoothly so that the springs are compressed in a controlled manner.

The airbrush is held much like a paintbrush. Using the thumb and middle finger to support the body of the airbrush, the index is used to activate the trigger (A).

The wrong way to activate the lever, as practiced by many beginners. This makes it very difficult to control the pressure exerted on the lever; also, the position is extremely uncomfortable.

The correct use of the lever involves pressing downward and toward the rear. Depressing the lever all the way produces the greatest amount of spray. If you gradually push rearward on the lever, you will produce the right amount of paint (C).

USING THE TRIGGER
The activating lever must be used gently, progressively pushing downward and rearward until the paint comes out. The rigid position and uncontrolled pressure that people experience in the early stages of this technique make it harder to produce lines and make the work flow.

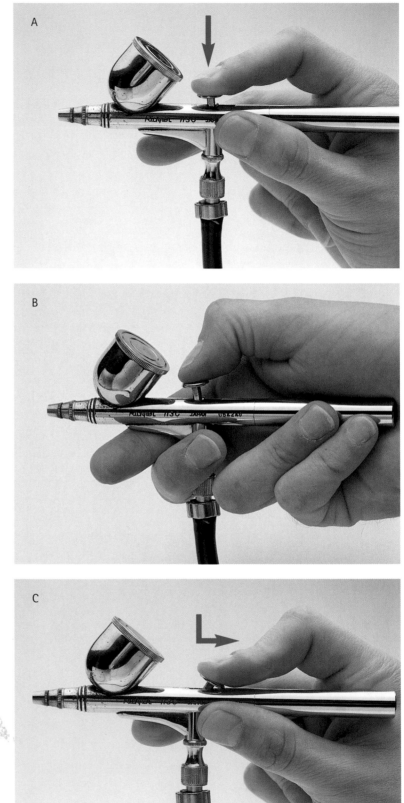

A

B

C

Filling the Paint Cup

Most airbrush paints come in containers with droppers that make it easier to load the paint into the cup of the airbrush. If you use other paints, you will have to prepare them separately, diluting them to produce a very fluid consistency. Also, the process varies according to whether you work with straight colors or mixtures. Sometimes it's a good idea to do the mixing separately to be sure you get the right color.

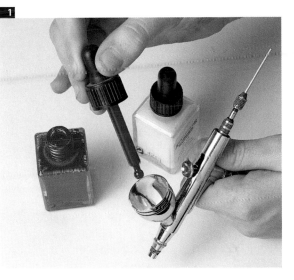

1 Acrylic airbrush paints have a cap with a dropper for transferring the color into the cup. For mixing, red and white in this case, the colors are added one after the other.

2 When the paints are in the cup, mix them together with a brush and check the resulting color shade. If you want a shade closer to white, add a few more drops of white; if you want a darker shade, add a few drops of red.

3 If you are using oils, gouaches, or any paint from a tube, you will have to do a little preparation before putting them into the color cup. Do the mixing in a separate container in sufficient quantity, until you get the right shade.

4 Once you have the color you want, use a brush to scoop it into the paint cup. By this point, you will have added enough solvent to make the paint liquid.

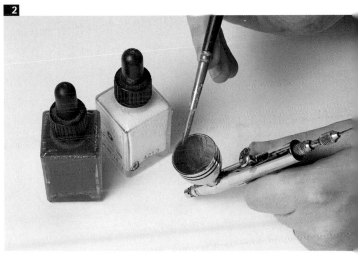

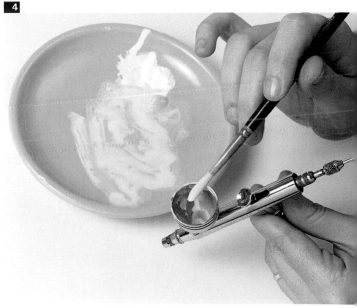

Cleaning the Airbrush

The airbrush is a complex tool. It's made up of small internal parts that are continually exposed to paint, so they get dirty easily, and if they aren't cleaned properly they can gum up and make the instrument inoperative. That's why it's important to clean the airbrush every time the color is changed and at the end of the work session; also, cleaning prior to use assures that all residue has been removed.

Simple Cleaning

It's a good idea to clean the airbrush every time the color is changed. If you go from a light color to a darker one, you can clean merely with water; but if you go in the other direction or use a thick color such as white, you will have to use alcohol to remove all traces of paint.

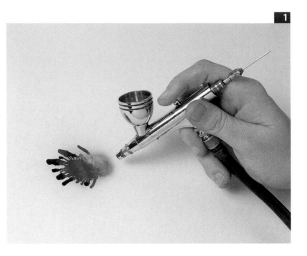

1 First, you need to activate the trigger so that the airbrush will expel any excess paint inside it. Repeat this operation several times until no more paint comes out.

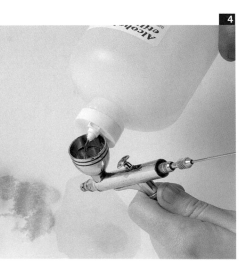

2 Immerse the paint cup in a large container filled with water to remove any leftover paint.

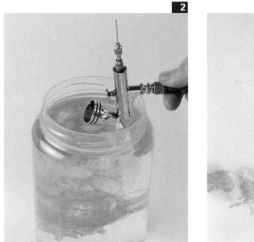

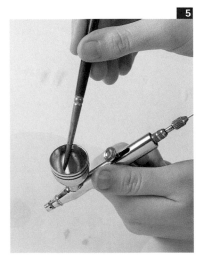

3 Since most airbrushes get damaged because too much pressure is applied to the trigger, as we have indicated, it's a good idea to empty the color cup again through the needle by loosening the chuck nut and pressing rearward.

4 Fill the paint cup with alcohol.

5 Use a brush to stir the alcohol around and dissolve any remaining paint.

6 Clean the nozzle with a brush soaked in alcohol, since any remaining paint in this area could contaminate a new color or obstruct the flow if it dries.

7 Take the needle out of the airbrush.

8 Use a piece of cotton soaked with alcohol to clean the needle and remove impurities. Then, put it back into place and install the chuck nut.

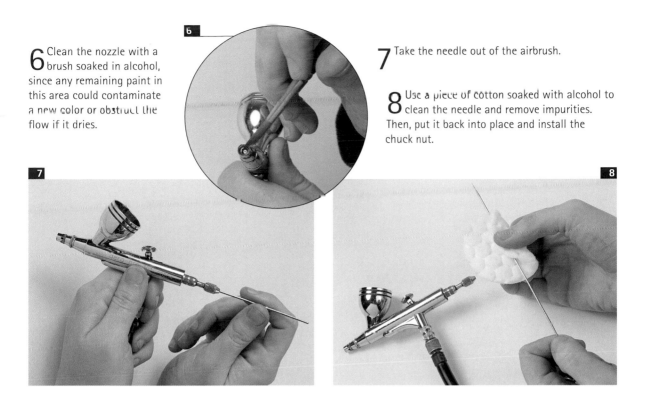

Thorough Cleaning

The preceding steps provide a thorough cleaning of the airbrush and leave it ready for subsequent sessions. But sometimes the airbrush is clogged or so dirty that alcohol isn't enough. In such cases, the airbrush needs to be submerged for several hours in a container with detergent and very hot water, and the needle must be unscrewed so that the soap penetrates inside and cleans the inner parts. If necessary, you can renew the water and soap until all traces of the paint are gone. If in spite of all this the tool is not sufficiently clean, you will have to take out all the parts of the airbrush and wash them individually.

Any grease-cutting soap is good for removing the leftover paint stuck to the body of the airbrush.

CLEANERS
Water and alcohol are the main products used for cleaning the airbrush, and they are usually adequate. There are other products specifically made by some companies for cleaning and lubricating the airbrush efficiently. These products act like metal cleaner and protect the tool without causing rust or other damage.

Making Dots and Straight Lines

Making dots allows you to control the relationship between the air pressure and the paint and the distance between the airbrush and the surface. Beginners tend to activate the trigger and pull back without much control. By doing dots, you can pull back on the trigger progressively and observe how the airbrush and the spray act, depending on the quantity of paint and the distance involved.

Once you master distance and pressure, you can start to control the drawing process. Drawing lines with the aid of a straightedge helps you develop a steady hand and confidence as you hold the airbrush.

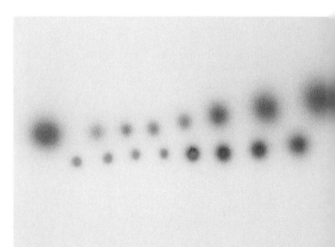

Dots help you control the area covered by the spray. The airbrush is held with the trigger depressed while pulling back gradually. In the smallest dots the lever is pulled back only a little and the airbrush is close to the paper. In the largest dots, the airbrush is held at a greater distance from the paper and the lever is retracted farther.

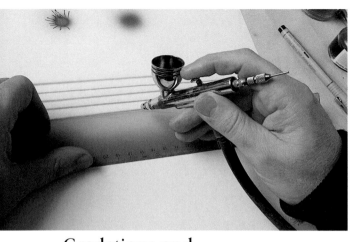

In doing these lines without difficulty, you need to work deftly, making the airbrush slide on the straightedge without stopping at any point. That will produce an appearance of continuity with no unevenness.

Gradations and Smooth Backgrounds

Backgrounds allow control of the airbrush at significant distances, and in contrast to what you may think, it requires skill so create a uniform gradation without accumulations of paint. You have to work with the airbrush held far from the paper and the needle retracted to release a lot of paint. Because of the distance from the surface, the paint doesn't become concentrated, but rather is spread out uniformly. Darker color concentrations are not created by holding the airbrush closer to the paper, but by using successive passes to keep the paint from accumulating unevenly.

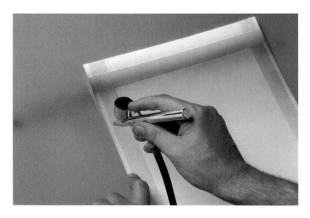

It's important to spray right past the established margins. This way, the results will be homogenous, with no paint accumulations at the edges.

Gradation from 100% to 0. You work from the dark area on one side to the white on the other.

Error Chart

No matter how much you practice, it's not easy to use an airbrush. There are always errors and problems, sometimes due to lack of experience, and others because the tool is out of adjustment. We will now present the main difficulties that may arise and how to avoid or correct them. In any case, some problems are due to the improper functioning of the airbrush, which will have to be repaired by a specialist or replaced with a new one.

AVOIDING PROBLEMS
It's important to keep the tool in perfect condition and absolutely clean every time the color is changed, and especially at the end of a work session. Also, the paints must be kept tightly closed to keep them from drying out, and they must be diluted with a little water to keep the consistency fluid and avoid clogging the nozzle. The nozzle needs to be cleaned constantly to keep paint from accumulating and interfering with the paint flow.

Errors with Lines

ERROR: Blotching.
CAUSE: Runny paint. The airbrush is too close to the paper. The needle valve is opened too wide.
SOLUTION: Thicken the paint. Hold the airbrush farther away to reduce the impact with the paper. Correct the position of the needle.

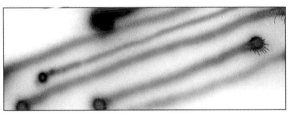

ERROR: Mottling.
CAUSE: Lack of air pressure. Paint too thick or poorly mixed. There are pigment particles in the orifice or inside the airbrush.
SOLUTION: Adjust pressure. Empty and clean the airbrush and prepare a new mixture. Take apart the airbrush and clean it meticulously.

ERROR: Mottling at the beginning and end of the lines.
CAUSE: The trigger was released too quickly.
SOLUTION: Release and squeeze the trigger more softy.

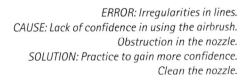

ERROR: Irregularities in lines.
CAUSE: Lack of confidence in using the airbrush. Obstruction in the nozzle.
SOLUTION: Practice to gain more confidence. Clean the nozzle.

ERROR: Lines are too broad.
CAUSE: The needle is damaged. The nozzle or the tip may be installed incorrectly.
SOLUTION: Change the needle. Install the tip and the nozzle correctly.

Problems with the Tool

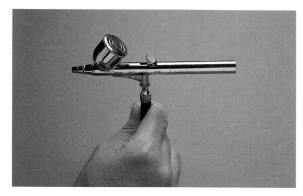

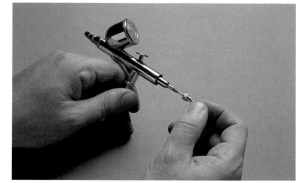

PROBLEM: The trigger doesn't return to its original
position after use.
CAUSE: There's not enough tension on the valve spring.
The trigger may be broken.
SOLUTION: Tighten or replace the spring.
Seek professional repair.

PROBLEM: The needle sticks inside the airbrush.
CAUSE: There is dried paint inside. Damage caused by
improper use.
SOLUTION: Immerse the airbrush in water and carefully
free up the needle. Seek professional repair.

PROBLEM: The paint flow is interrupted.
CAUSE: The paint is too thick. The needle fits too tightly
inside the orifice. Lack of paint in the reservoir. Damaged
control level. Dried paint obstructing the nozzle.
SOLUTION: Dilute the paint. Take out the needle and check
the chuck nut. Fill the paint cup. Seek professional repair.
Dismantle and clean the nozzle and needle.

PROBLEM: Air escapes through the nozzle and
produces bubbles.
CAUSE: The nozzle cap is loose or installed incorrectly.
Air supply has too little pressure.
SOLUTION: Adjust the nozzle properly. Increase pressure.

PROBLEM: Air escapes when the airbrush is not being used.
CAUSE: The air valve rod is improperly adjusted or the
diaphragm is broken.
SOLUTION: Professional repair.

Airbrush Procedures and Subjects

As with any fairly complex technique, the best way to learn airbrush skills is to practice with the greatest possible variety of subjects.

There is no single way to work with an airbrush, since every image requires a different order and materials based on color conditions. However, there is one characteristic that applies to all subjects: working in transparency. Thus, in order to avoid frequent masking, you can begin by using the darkest colors and then apply velaturas with the lighter ones without having to continue applying frisket film.

As a general rule, masking is used to separate areas of very different colors and specific shapes. However, in creating global shapes, it's common to use the airbrush freehand. Keep in mind that the higher the quality desired, the more the airbrush is commonly used freehand; flesh tones, animal fur, mists, cloudscapes, and so forth are subjects in which shading off works perfectly and masking is simple. In contrast, in logos and illustrations of a more graphic and conceptual nature, a more meticulous type of masking is called

◆

Each exercise will involve a different type of difficulty to include all the techniques that go along with the simple act of spraying.

◆

for, since you are creating very specific areas of color and very rigid shapes and structures using precise curves and straightedges. Resources include movable shields, which are good for individual colors, masking with glue paint for small areas, and so forth.

Even at more complex levels, as when working with a subject that requires a high degree of detail, the airbrush is the perfect tool because of its versatility. In addition, it's appropriate to recall that the work can be complemented by touching up with pencils or gouache, which help define the details that are beyond the capabilities of the sprayer.

On the following pages we will present a variety of subjects that will pose some challenges to the reader. These involve representing lusters and reflections, human flesh tones, the design and development of a logo, and the creation of fictitious characters for a children's story.

Airbrush is a very commonly used technique in designing signs and logos.

Textures of an Egg White and Yolk

For this project, we will work with a very simple subject: a raw egg cracked onto a surface. The characteristics of each part are very different—the white, the liquid, viscous, shiny part with a slimy appearance; it's more liquid than the yolk, so its shape is flatter and spreads out over the surface. The yolk, on the other hand, has a semispherical and bulging form, and it produces a number of very specific reflections as a function of its shape. The shell looks more matte and subdued, even though the oval shape must be very well defined, both on the outside where it's convex and on the concave inner surfaces.

It's important to understand the chromatic relationships in the entire picture, since certain elements are transparent. The shell and the yolk have their own clearly defined colors; however, the color of the white depends entirely on the background. The relief is communicated solely on the basis of chiaroscuro contrasts, but with a general color identical to that of the surface. It's appropriate to emphasize the importance of contrast in representing transparencies, since it corresponds to the areas where light is not reflected and it must show the outline and the shape of the object.

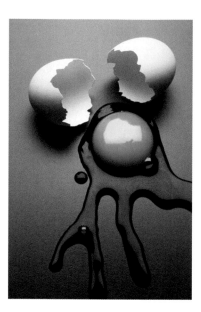

The shine and the coloring of this image make it ideal for the basis for a very realistic airbrush illustration that remains faithful to the model.

MATERIALS
- Airbrush
- Various acrylic paints or liquid watercolors
- Graphite pencil
- Colored pencils
- Satin-finish airbrush paper
- Frisket film
- Scalpel-type hobby knife
- Tracing paper

1 Once the subject is drawn on the paper, cover it entirely with frisket film, making sure it is completely flat and free of air bubbles. After covering the entire paper with plastic, cut out the different shapes using the scalpel knife. Do this slowly and carefully so that the cut follows the pencil lines perfectly.

TECHNIQUES USED
- ◆ Airbrush with acrylic paints ◆
- ◆ Frisket film ◆
- ◆ Blocking out with tracing paper ◆

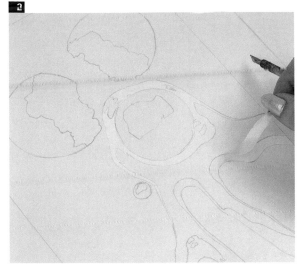

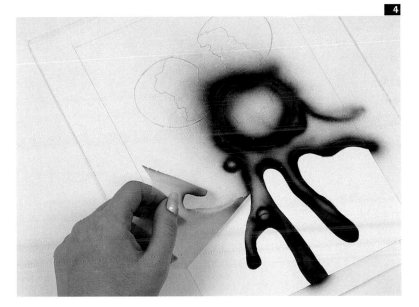

2 Next, unstick the masking that corresponds to the dark part of the egg white, made up of certain curved shapes that surround the yolk, and establish the silhouette and the outline of the liquid. These shapes were already drawn as part of the composition in establishing the contrast between the dark and light areas.

3 Next, spray the uncovered part with straight black. Emphasize the passes with the color so that the black is very intense, both in the area that surrounds the yolk and in the remainder of the outline.

4 Once the black for the contrast is in place, remove the masking from the background. Now you can see that the outline is perfect and that the paint has not gotten into the masked area.

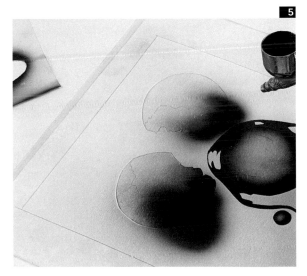

5 After removing the masking from the background, add the color to that part of the illustration. In the area below the shell, you will add a shadow effect with a dark pass with black. The idea is to first set up the contrasts among the elements and then color them through transparency.

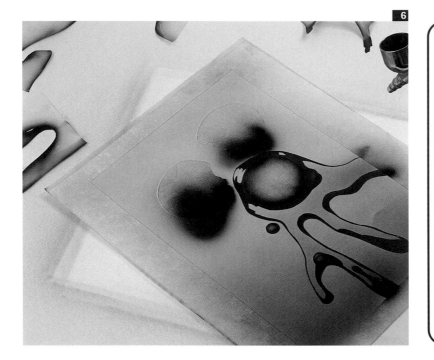

6

COLOR ORDER

Painting by transparency saves us from using masks. The transparencies can be done from light to dark or from dark to light. The latter is the choice for this exercise. Of course, in working by transparency it's essential to use transparent colors that don't completely cover the background color over which they are applied. This exercise involves starting with dark black that is subsequently shaded off through transparency without using frisket film.

6 After replacing the masks on the shells, the yolk, and the egg white, color the background with the airbrush held at a distance from the paper. Since this involves covering a large surface, work far from the paper and use as many passes and cups of paint as necessary. In the lower part, the color is darker, and at the top, a more transparent effect can be created by using fewer passes with the airbrush.

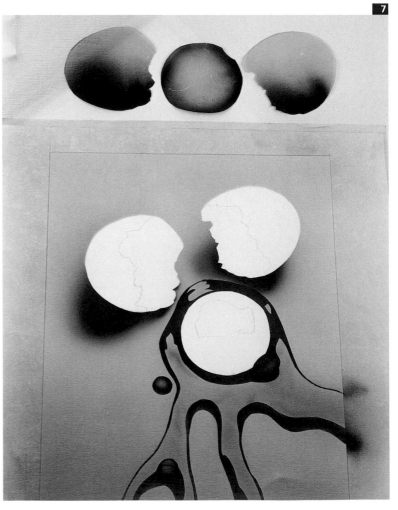

7

7 Now the masks are removed that correspond to the eggshells and the white, and we can see that the outline remains perfect. The effect of the egg white and the background has already been pointed out, and it creates a complete sensation of transparency using contrasts and the similarity of color between the surface and the liquid.

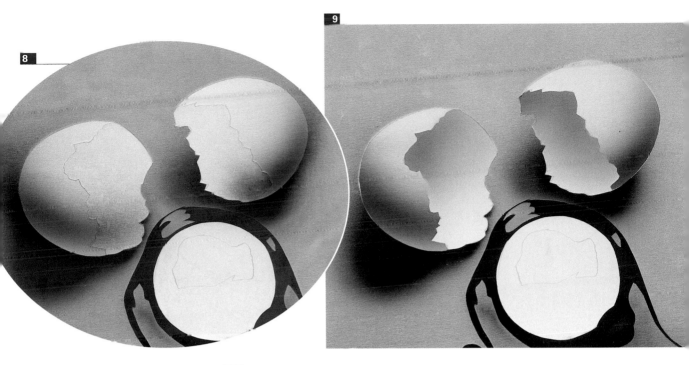

8 Mask the area that surrounds the shell, first covering the entire surface and then cutting the outline of the break so that both surfaces are uncovered. A sepia tone is used to give volume to both parts and produce a darker area at the bottom.

9 In this step, both shells have been colored outside and inside. On the outside the shadow is on the lower part, but inside the top is darker. This technique imparts a very clear shape. There are some warmer and very light shades in the illuminated parts of the background.

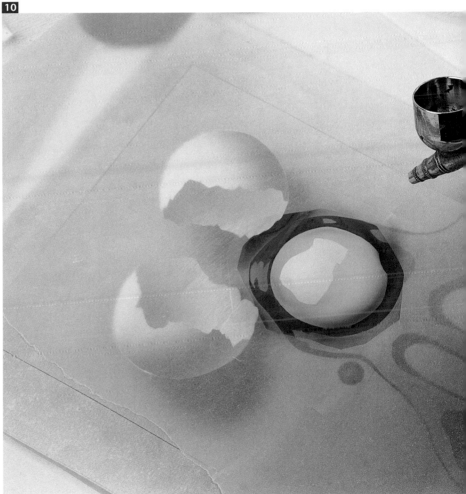

10 Color the yolk using straight orange, and mask the rest of the paper as you do that. Use tracing paper to cut out a circular part in the middle; you use just a small piece of frisketing that corresponds to the outline of the yolk. Next, cut out the exact shape and apply the color.

COLOR AND TEXTURE
By finding the right color for every texture, you create a completely photographic image.

11 Finally, the color of the yolk is done in two phases, one of which produces a lighter color that corresponds to the shine, and another darker one for the outline, for which more passes of color are applied. The result is an illustration with a lot of visual impact and a highly realistic result, with accuracy in the colors and the contrasts.

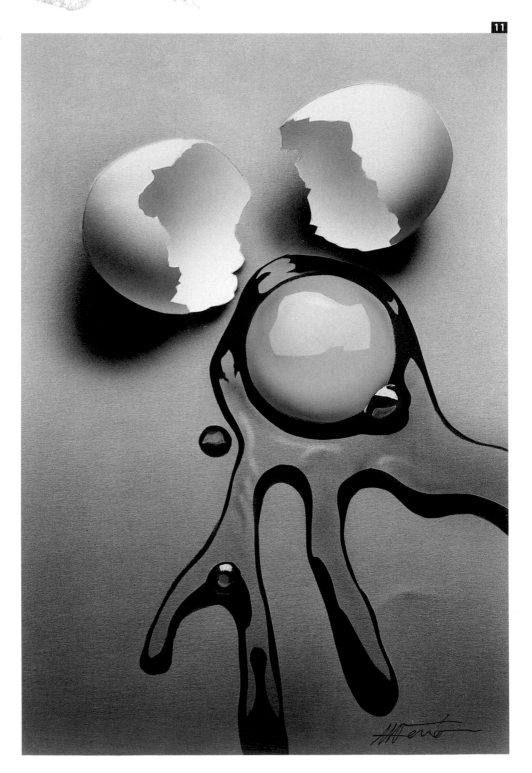

11

Metallic Shine on a Musical Instrument

Metal and glass reflections always follow the shape of the object. To be sure that the position is correct, you have to maintain a constant viewpoint in relation to the object. For that purpose, the easiest technique is to use a photograph. Metallic reflections are difficult for inexperienced painters to control; the most important thing in such cases is to understand that on metals lights and shadows are projected as in a mirror, but they follow the outward shape of the object. Lights and shadows are well defined, so they can be formed perfectly using frisket film or movable shields. The contrasts will always be well defined, especially the greatest shines and the dark areas.

In the following exercise, we will work with a gold-colored metal, and the overall color will be a yellowish shade onto which the whites and blacks that communicate the contrasts will be added. The shape is absolutely decisive in locating the contrasts; due to the many curves and features, it's a good idea to draw them slowly and by pieces, always following the outside profile of each segment.

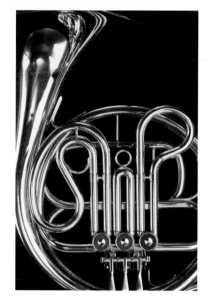

Reflections on metals are very striking and are a perfect subject for creating maximum contrasts between light and dark.

1 First, do a detailed drawing of the shape of the horn on the paper. Clearly, its complex shape establishes a multitude of curves that are more easily drawn with the aid of a template.

MATERIALS
- Airbrush
- Various acrylic paints or liquid watercolors
- Graphite pencil
- Colored pencils
- Fine-tip black marker
- Gouaches
- Satin-finish airbrush paper
- Frisket film
- Scalpel-type hobbyist's knife
- Tracing paper

TECHNIQUES USED
- ◆ Airbrushing with acrylics ◆
- ◆ Using curved shields ◆
- ◆ Using colored pencils and gouache ◆

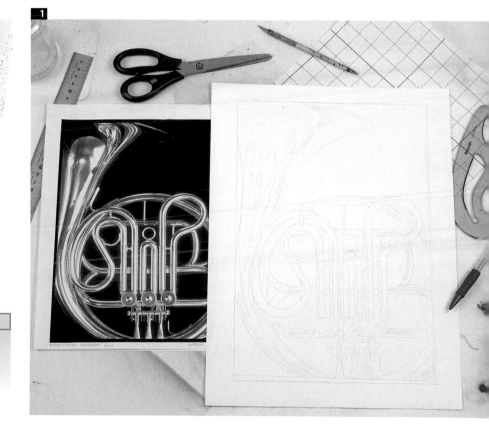

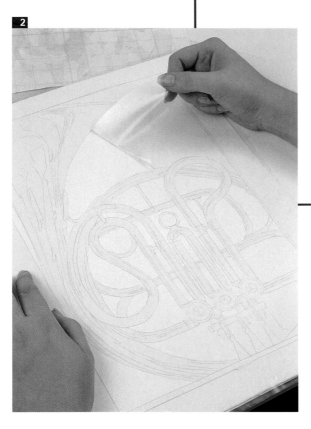

THE CUTTING PROCESS

Cutting out the masks is more important than it may seem at first. Cutting the frisketing is almost like drawing the subject once again, with total regard for the outlines and keeping the line firm and even. The cut needs to be shallow—in other words, with so little pressure that the paper is not damaged, for only the frisketing is to be cut. With radiuses, regular curves, and straight lines, you can use prefabricated templates as an aid in achieving a firm, continuous cut.

2 Use the hobby knife to cut around all the outlines. This is a painstaking task, since the superimposed curves and shapes mean that there are bits of background among the different parts of the horn. Carefully remove the masks for the background and set them aside.

3 Use straight black to color in the background part. As in the previous exercise, this is a large surface that requires working from a distance and keeping the color cup filled.

4 Once you are sure the paint is completely dry, carefully remove the frisketing that covers the horn.

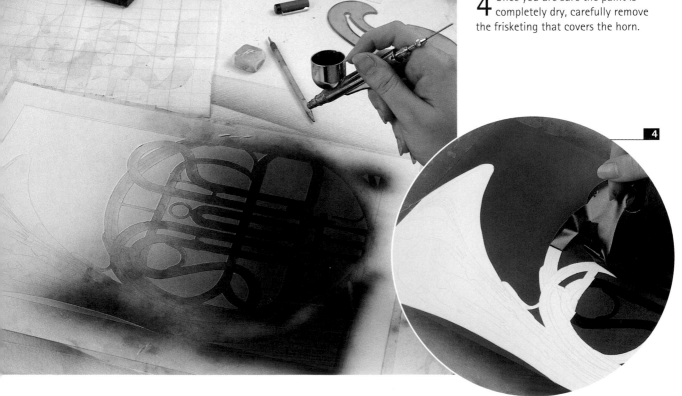

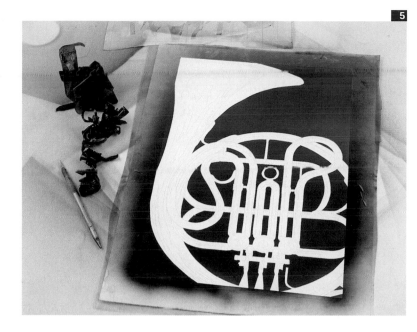

SEPARATING BACKGROUND AND FIGURE

Airbrushing requires a separation of work phases more than any other technique. The continued use of masks means that the areas of color are separated from one another and worked on one at a time, adding the appropriate contrast in each case.

5 After removing the masking, you can see the outline of the instrument perfectly clearly. The background has been colored with a black base toward the bottom and a dark ultramarine blue at the top, which adds variety to the whole illustration

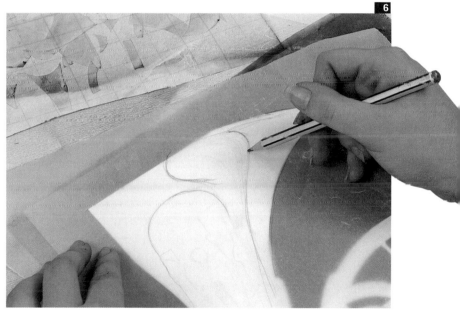

6 Using tracing paper, mark the dark areas on the upper, broad area of the horn. Since this paper is semi-transparent, the object is to draw the curves that will serve as movable shields and cut them out separately.

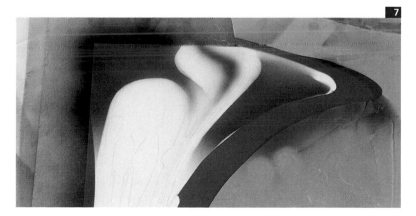

7 Note that the movable shields work wonderfully in creating the dark contrasts in the bell of the horn. The color of the shadows is straight black, blending the coloring on the instrument with the background.

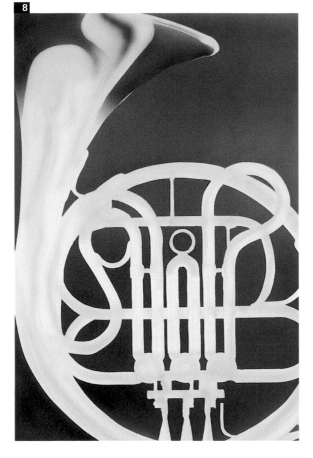

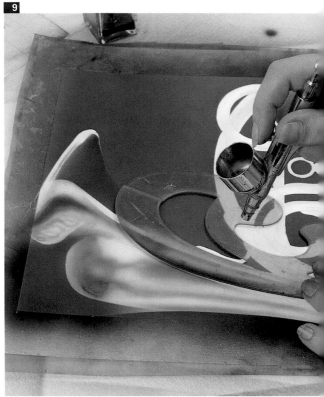

8 Next, add the general color to the entire surface of the horn using pure yellow, but leaving some more transparent areas that show the color of the paper where pure white will show. It's not necessary to mask the background since we are using a very light color that will have no effect on the dark black, even when we go beyond the borders.

9 Use sepia to work on some intermediate colors that comprise the upper part, where they are broader and more visible. To keep the shapes consistent with the outline, you can use a curved template like a movable shield.

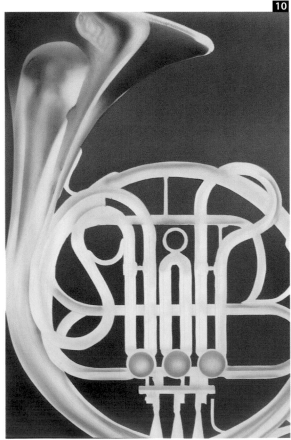

10 Here the broad, general coloring with black, sepia, and yellow has been completed. The effect is one of volume and contrast appropriate to metals. The rest of the areas will be worked in linear fashion, since they involve tubular shapes that are much finer and more specific.

HOW FAR CAN YOU GO WITH THE AIRBRUSH?

Airbrush is a technique that is reinforced with pencils, markers, and gouaches. You have to analyze how precise the spray is, the areas where it's the best choice, and the other places that require the precision of other techniques. Backgrounds and large features come out perfectly when airbrushed freehand, and intermediate areas can be done with cut-out masks, but for linear features and tiny areas it's more appropriate to create the lines using other methods. Markers and gouaches are dark; for softer shades, colored pencils are a better choice.

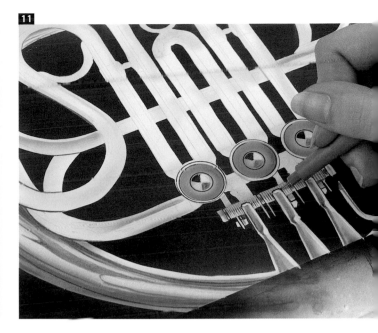

11 The details are added piecemeal, given the complexity of the curves. The valves and springs are reproduced in the lower part with the aid of a fine-tip black marker.

12 Now the greatest reflections are highlighted using straight white gouache. As you can see, both lights and shadows follow the outer shape of the object. With curves, the reflection follows the same tendency, and in narrow areas these reflections are fine and must be done with a brush rather than masking.

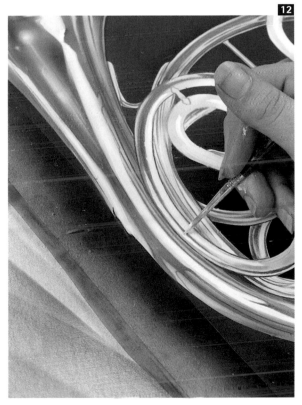

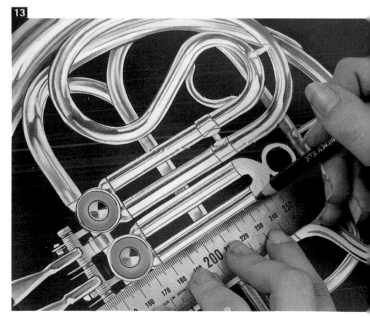

13 Now we arrive at the middle part where the tubing is straight. In this case the reflections and contrasts are done with the aid of a straightedge and a black pencil so the result is perfectly precise and vertical.

ADDING DETAILS

In this exercise, the large colored areas are done by spraying, and the finest and most specific details are done using pencils, gouaches, and markers.

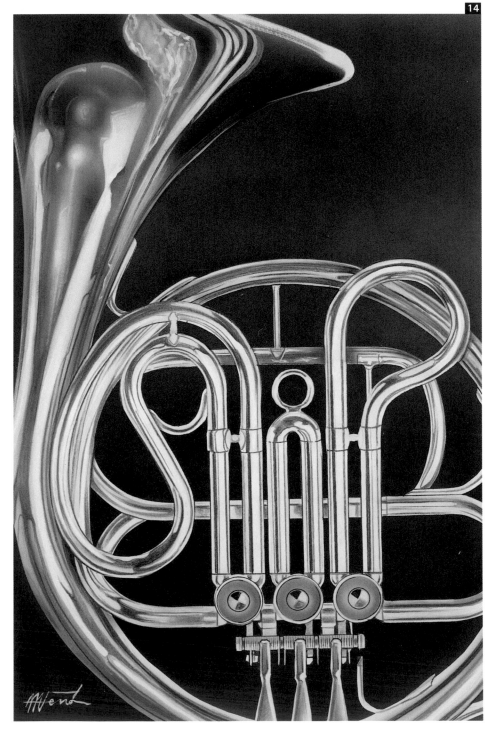

14 Finally the contrasts in all the parts of the horn have been established, starting with the broadest and most general areas and finishing with the most slender tubing. The result is very striking because of the contrast between the brightness of the instrument and the dark background.

Aladdin and the Genie

Illustrations for children continue to fill a very important role in the field of airbrushing because of their capacity to create any type of character or fantastic scene in a very realistic fashion. Children's illustrations are a part of many storybooks and other types of entertainment for very young children, including animated films. Children identify better with direct, simplified drawings, so details often become superfluous. In designing a drawing with these characteristics, we have to keep the shapes simple, clear, and of course, amusing and visually attractive, especially with respect to color.

Themes are extremely varied, and any idea may work well. For this image we will develop a scene from the story Aladdin and the Magic Lamp. On the level of airbrush technique it's appropriate to point out the smoke that engulfs the figure of the genie as he mysteriously appears. With respect to characters, the airbrush can be used for creating all kinds of shapes to give them a more realistic appearance.

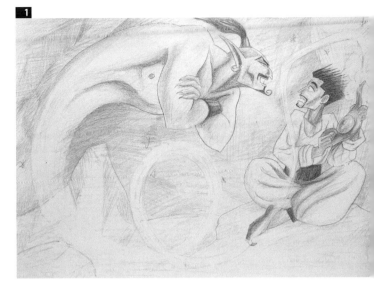

1 First, we need a preliminary sketch showing the outline and the nature of the characters. You may have to do several attempts before you hit on the style you want. The sketch will involve all the concepts important in the final drawing—movement, anatomy, and so forth.

MATERIALS

- Airbrush
- Various acrylic paints or liquid watercolors
- Graphite pencil
- Colored pencils
- Gouaches
- Satin-finish airbrush paper
- Frisket film
- Scalpel-type hobby knife
- White airbrush board
- Scissors

2 Next, cover the whole paper with frisket film and cut out the shape of the genie. Then, using the airbrush freehand, spray the contours and the main shapes. Work with warm colors, yellows and greens, to give the character a totally fantastic appearance.

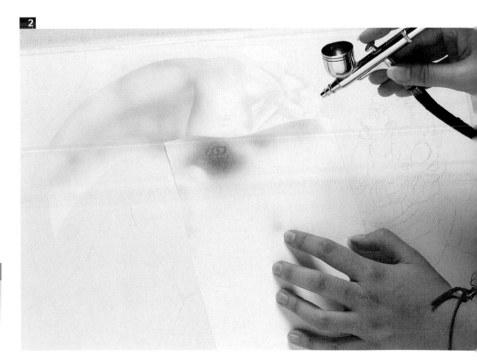

TECHNIQUES USED

- ◆ Airbrushing with watercolors ◆
- ◆ Using movable shields ◆
- ◆ Detail work with gouache ◆

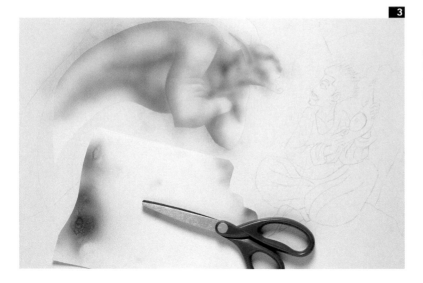

3 Now the genie is colored in using greenish shades. A movable shield made from white illustration board cut to the right shape has been used in drawing the separation between the arms and the body.

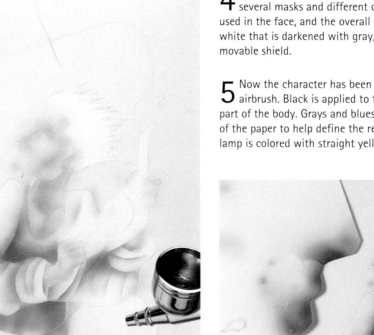

4 Next, the character of Aladdin is developed using several masks and different colors: pink, pale colors are used in the face, and the overall color of the clothing is white that is darkened with gray, with the aid of another movable shield.

5 Now the character has been colored in using the airbrush. Black is applied to the hair and the hidden part of the body. Grays and blues alternate with the white of the paper to help define the rest of the clothing. The lamp is colored with straight yellow.

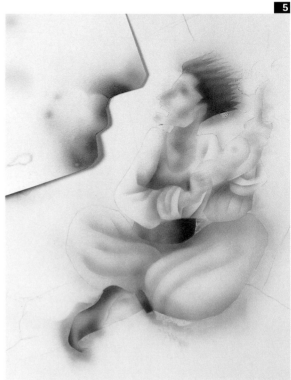

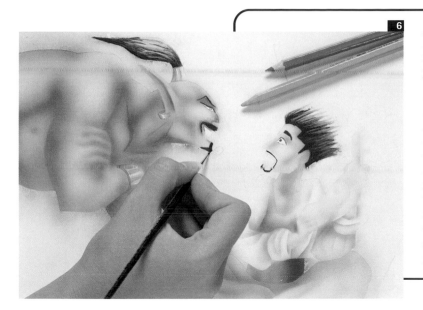

**THE AIRBRUSH
IN ILLUSTRATIONS
FOR CHILDREN**
The airbrush has many
advantages in creating fantastic
images. The spray creates very
realistic shapes because it
leaves no perceptible marks
on the paper. This technique
is wonderful for designing
fantastic characters, and
the greater the detail, the
more striking the results.
Contrasts and the characters'
surroundings are essential for
making the scene more credible.

6 The details are added with the aid of gouache colors. A fine brush is used for the specific details of the face, such as the shape of the eyes and the character's mustache and goatee. Note that the strokes with the brush fit in perfectly with the airbrushed colors.

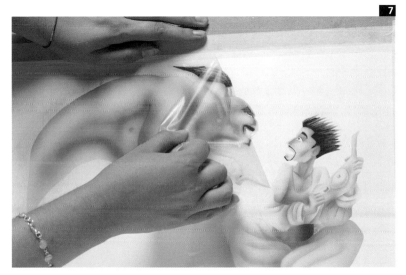

7 Once the details are added and both characters are colored in, remove the masking from the background. Note that the outlines are perfectly neat and well defined.

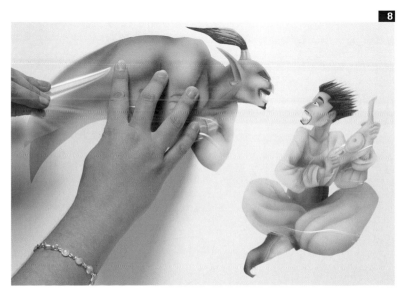

8 Now reverse the process, that is, mask the characters to protect them while you work on the background. Remember that the colors applied with the airbrush and gouache must be perfectly dry so that the new masks don't pull them off or alter them.

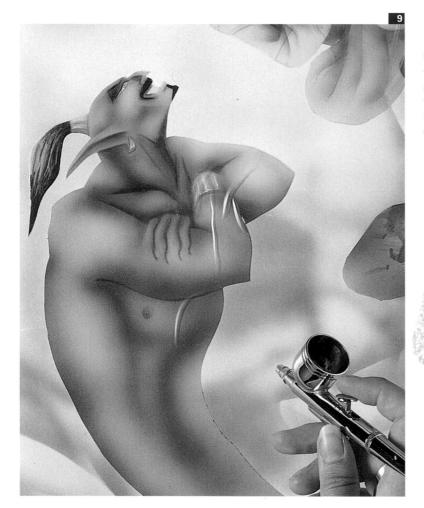

9 Once the figures are protected, color in the cave with a shade of brown. Keep the airbrush fairly far from the surface in filling such a large area. Cut out a few movable shields to create separation among rocks in highlighting the shapes inside the cave.

ANOTHER WAY OF WORKING
In this instance the characters are first created in detail, and then the background is handled in such a way that the contrasts and color values in the figures fit in with the surroundings.

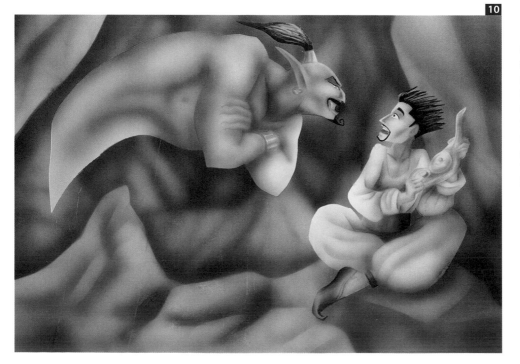

10 To create darkness and depth, some sepia has been added to the background. The darkening of the cave really causes the colors and the figures to stand out boldly.

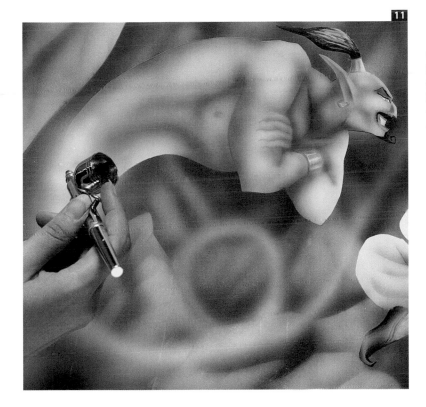

11 The smoke that surrounds the figure of the genie is done with a spiraling pass of white. White is a dense color that covers well, so it stands out well on the dark background of the cave at the same time that it blends in perfectly with the figure of the genie.

12 Finally, a little shade of green is added to the white of the smoke to bring it a little closer to the general coloration of the genie. Overall, this is an imaginative and amusing work.

Designing and Creating a Logo

Another very important part of modern airbrush art involves creating logos and designing letters and posters. Despite the significant presence of computers in this field, there is a preliminary step in which the graphic image is designed before being produced. Before the expansion of the computer field into graphics, the most spectacular way of creating a logo was with the airbrush, which endows letters with relief and luster, as if they were truly three-dimensional shapes.

The purpose of this exercise is to create a visually attractive image to emphasize the technique with which we are working. Color complements and reflections are basic to creating all kinds of effects that have great visual impact.

1 The first step involves doing a sketch of the logo. The first sketches are commonly done in black and white, with the idea of studying the shape of the letters and the design; then the work is done in color to find a color correspondence. The logo is made up of several features besides the letters, such as a diamond behind the image of an airbrush that indicates the tool referred to by the text.

MATERIALS

- Airbrush
- Various acrylic paints or liquid watercolors
- Graphite pencil
- Colored pencils
- Black fine-tip marker
- Gouaches
- Satin-finish airbrush paper
- Frisket film
- Scalpel-type hobby knife
- Straightedge
- Tracing paper
- Glue paint

2 As in the previous cases, the sketch is drawn onto the paper, covered with frisketing, and gone over with the scalpel. Now we proceed to paint the airbrush, so we unmask the parts that correspond to the dark areas of the airbrush shape and spray them with straight black.

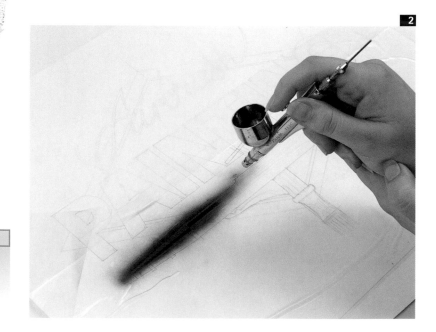

TECHNIQUES USED

◆ Airbrush with acrylics ◆
◆ Freehand lines ◆
◆ Blocking out with glue paint ◆

METALLIC SHEEN

The sheen of metals is rendered through contrasts between light shades, plus black and white. The cold shades are done in light blues, purples, and blacks. Chrome and gold colors require the use of a warm color scale of yellows for gold and reds and browns for chrome. In fact, all metals, regardless of their color, can be done with black in certain areas.

3 Now that we remove the remaining masking from the airbrush shape, we can see the main reflections that a metallic instrument like this one produces.

4 Some new soft purple and bluish velaturas are added with the airbrush; these establish the chrome of the tool. Next, the mask is removed to check the color contrast with the white background. A purple pencil line can help reinforce certain straight shapes in a shade between black and white.

5 Next, cover the whole paper with tracing paper and cut out an elongated box the size of the main letters. Cover the box with frisket film and cut out the silhouette of each letter. A straightedge is essential in cutting out the straight shapes.

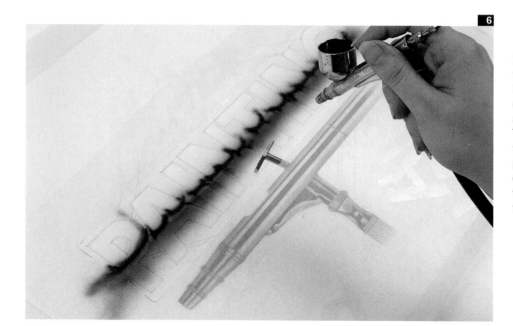

6 Use purple to color in the lower part of the letters. The intermediate area is darker, so the color is applied more heavily. Toward the bottom the density of the paint is reduced to create a gradation from the middle to the lower part.

7 Next, the upper part of the letters is colored in with a smooth pass of blue. This will help create a chrome effect. Once this step is completed, remove the frisketing and check the effect of the color and the cut-out silhouette of the word.

8 The silhouettes of the airbrush and the word have been colored. Now frisketing is applied once again and the silhouette is cut out so the background can be colored in. Uncover the shape of the first diamond, and before coloring it in, paint over the cursive letters using glue paint to create a linear effect.

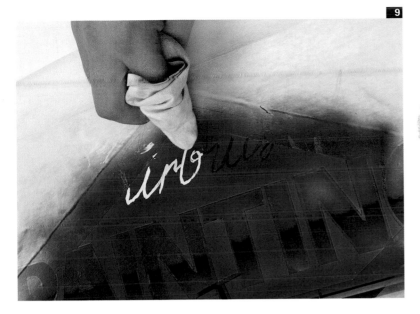

USING GLUE PAINT
Before removing the glue paint, make sure that it's completely dry. Once it's dry and solid it's easy to remove, but when it's still wet you run the risk of removing part of the surrounding color as you rub with the rag.

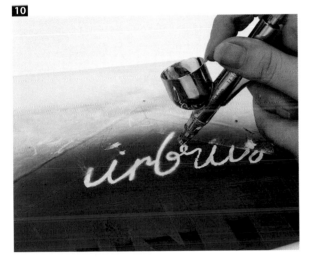

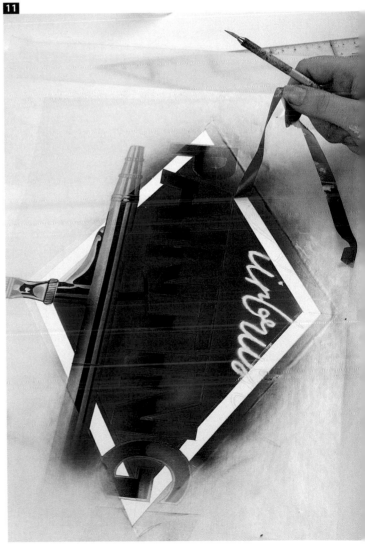

9 Now the diamond is colored in with a deep sapphire blue. The letters and the shape of the airbrush are blocked out. The word Airbrush has been covered with glue paint that is removed with a rag once dry, thus exposing the real shape of the letters.

10 Holding the airbrush very close and using white paint, go over the letters on the blue diamond so that the edges have a more wispy appearance and the line is less precise.

11 Now the masking is removed from the outside of the diamond, which was previously cut out. The letters and the airbrush are still blocked out with frisketing. This is a slow and meticulous process.

12 Color in the outer edge of the diamond with yellow and add a velatura of orange at the two ends to give it more presence. As you can see, the rest of the features are still masked to preserve their original color.

13 Once it's dry, remove all the masking from the logo. Now we have an initial reference for the visual impact of the whole project. Now we will apply the details freehand.

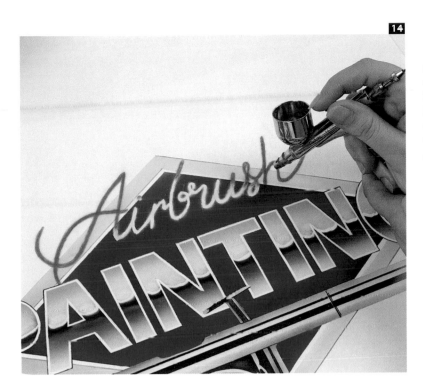

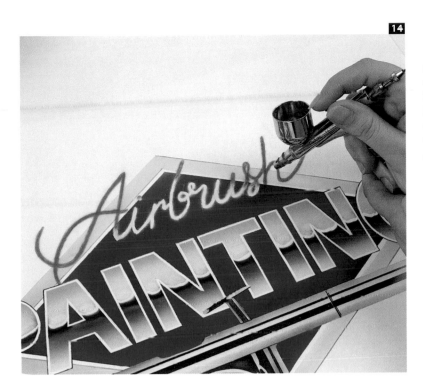
14 Go over the letters of the word Painting with a black fine-tip marker so they are clearly defined, especially in the inner areas that are in contact with the white of the paper. In the word Airbrush, the airbrush is used up close to follow the shape of the letters and create a misty visual effect.

15 Finally, we have a very striking color logo that has involved many airbrush resources, such as using various masks and liquid masking. Also, the word Airbrush, done freehand, shows a mastery of lines done with the tool held close to the paper.

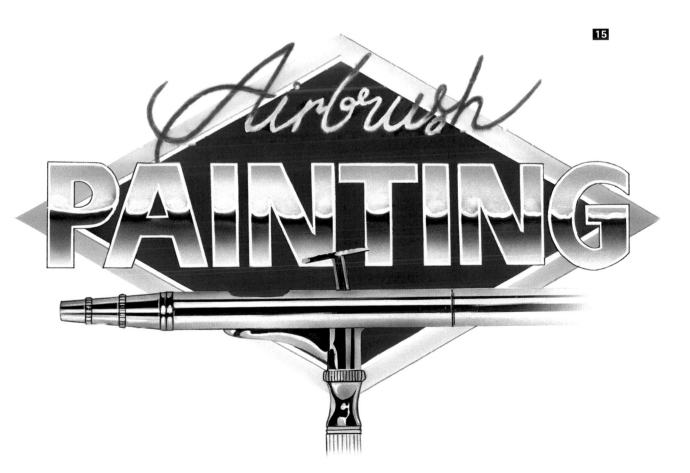

The Witch from *Snow White*

Illustrating stories and fables allows each artist or illustrator to interpret freely. Illustrators must find their own world of shapes and figures and adapt it to the known, popular tale. In this case we will work with the figure of Snow White's stepmother, a beautiful but wicked woman, and her magic mirror. The appearance of the witch is entirely invented, so the facial features, the clothing, the reflections in the mirror, the environment, and so forth, are all products of the artist's imagination. Our artist has created a character with strong features and a slender and fashionable figure, just at the moment when she is preparing the famous tempting, shiny, poisoned apple. Obviously, something more than technical mastery is required for all this—it involves recreating an attitude, a certain scene that clarifies an episode that most people are very familiar with.

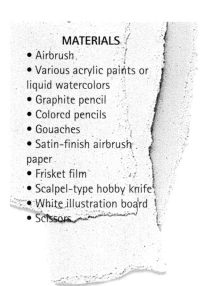

MATERIALS
- Airbrush
- Various acrylic paints or liquid watercolors
- Graphite pencil
- Colored pencils
- Gouaches
- Satin-finish airbrush paper
- Frisket film
- Scalpel-type hobby knife
- White illustration board
- Scissors

1 First, do a watercolor sketch to create the character's personality and her location in space. The artist has chosen a woman with strong, angular features with the apple in her hand and in front of a kettle in which she is preparing the poison; behind her is the magic mirror. This is commonly the most complex step, since it involves creating an image from square one.

2 Use a pencil to adjust the outline of the shape on airbrush paper. After this step, cover it with frisketing and cut out the shape of the woman for coloring with the airbrush.

TECHNIQUES USED
- ◆ Airbrushing with watercolors ◆
- ◆ Colored pencils ◆
- ◆ Creating white areas with an eraser ◆

3 Now color in the woman's skin using light sienna. Use very transparent passes over the paper to create a pale skin color. Use two pieces of card stock to block out the border of her neckline.

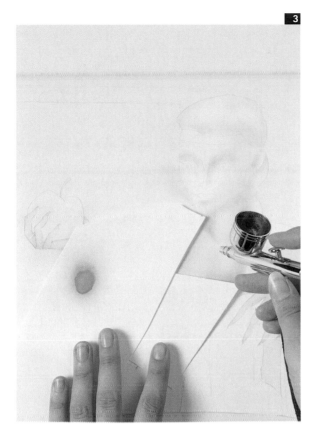

4 The skin has been colored in, and now the stepmother's dress is colored with an emerald green. The freehand work creates the shape of the body, the ribcage, and the hair; in this last instance, yellows and an ochre-colored pencil are used on the locks of hair.

5 Next come the details in the character's face and adornment. Gouache colors are the choice; a fine artist's brush is used on the eyes, the nose, the lips, and the elements of the hair. Then the apple is created, an important element in the scene, using carmine. The shine is created using a pencil eraser.

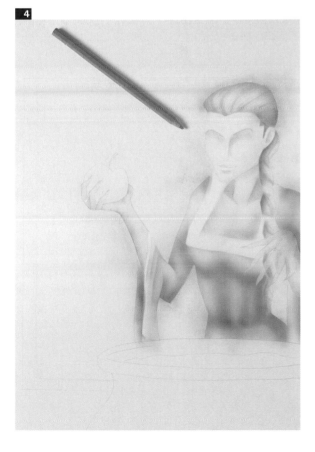

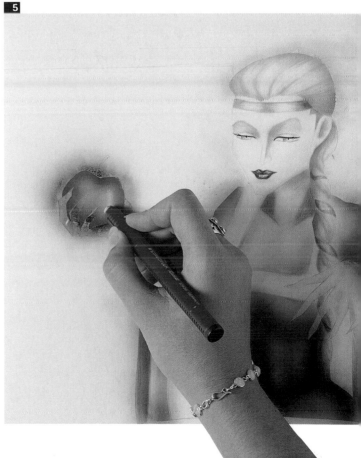

6 Next we tackle the kettle. It's large, and we start by working on the inside in carmine, like the poison that surrounds the apple. The rest of the kettle is unmasked so it can be colored in later.

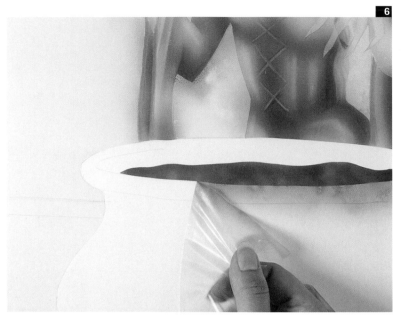

7 Now the kettle has been colored using brown mixed with other colors such as sepia and purple. These passes with the airbrush are light so that the interior of the container stands out from the other features. Next the surface of the mirror is covered with masking and we proceed to color the area around it.

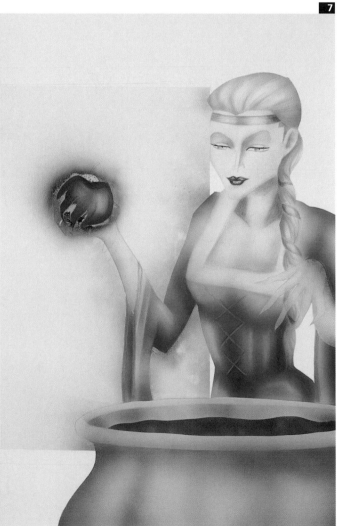

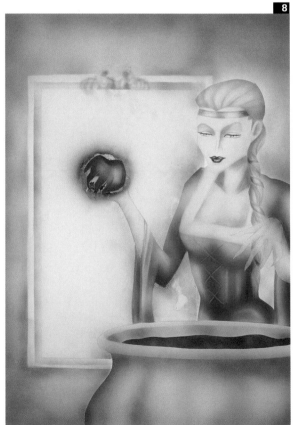

8 Now the wall around the mirror has been colored in. Straight yellow is used on the frame, creating several planes to suggest relief. The wall in the background is colored with very diffuse sienna.

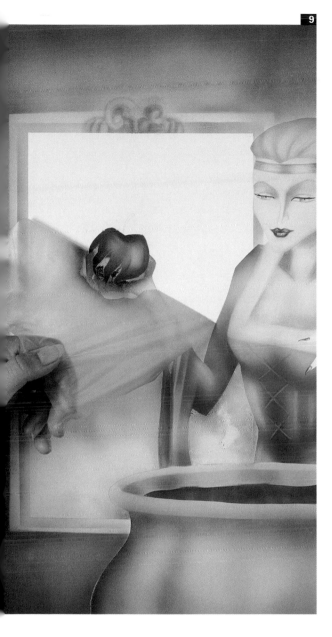

THE WORK PROCESS

The order of the steps in working with the airbrush depends entirely on the painter. Some prefer to start with the surroundings and then make the figure stand out adequately from the background. Others do the reverse, leaving the background vague and highlighting the shape and colors of the main figure. Whatever the case, the contrast in the work is crucial for creating realism under totally imaginary light conditions, as in this instance.

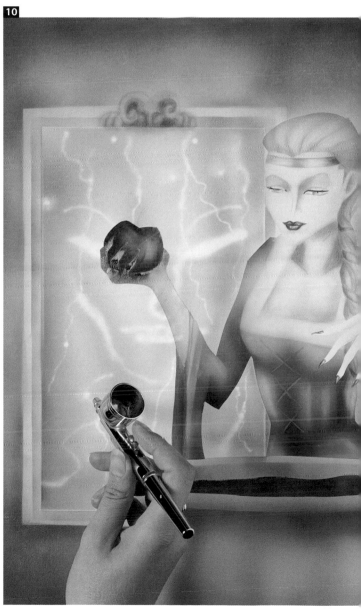

9 By removing the masking that covers the mirror, we see the contrast and the color intensity in the whole scene.

10 Next, gray is added to the surface of the mirror, keeping the shade light and transparent. Then straight white is used to draw lines on the gray and create reflections and a magical effect.

11 The illumination of the mirror with white reflections is now complete. To finish, the last details are added to the figure, such as the bracelets and the laces on the bodice. This is a simple illustration with strong narrative content that's just right for a children's drawing.

FREEHAND AIRBRUSHING
Creating shapes freehand allows us to work with an airbrush with the same liberty and fluidity as with a conventional brush. Clearly, not all images are appropriate for freehand work because the outlines have to stand out. However, the insides can be painted by holding the airbrush at a certain distance.

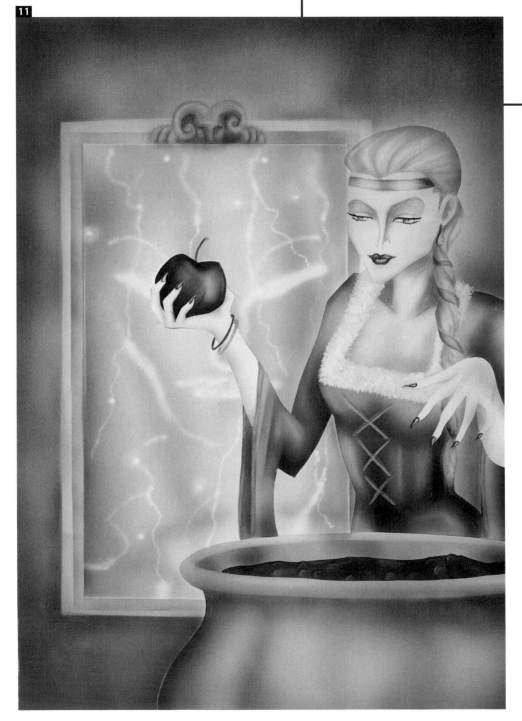

A Dolphin in the Water

The airbrush is commonly used for depicting animals, especially in illustrations that provide information about nature and fauna. There are many illustrations on nature topics for totally informative purposes that convey attitudes and poses that are hard to capture with a camera. Although animals can be drawn using any technique, scientific drawings tend to seek great realism and detail, so the airbrush has been gradually and successfully incorporated into this field.

Every animal, with its distinct morphological characteristics, involves a different kind of technique. This instance involves depicting a marine animal with a smooth, shiny texture. The dolphin's outward features and the water that surrounds it present a series of very important shines and reflections that require the use of an eraser and gouache or pencils to convey the power of light on marine elements.

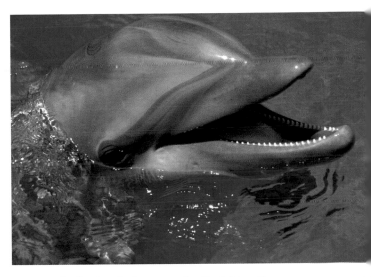

Shines and reflections in the water, plus the light on the dolphin's skin, make this a very striking and attractive image. Once again, the airbrush will be the best instrument for conveying lights and reflections with the greatest fidelity to the model.

MATERIALS
- Airbrush
- Various acrylic paints or liquid watercolors
- Graphite pencil
- Colored pencils
- Eraser pencil
- Electric eraser
- Gouaches
- Satin-finish airbrush paper
- Frisket film
- Scalpel-type hobby knife

TECHNIQUES USED
- ◆ Airbrushing with acrylics ◆
- ◆ Freehand airbrushing ◆
- ◆ Reflections with white gouache ◆

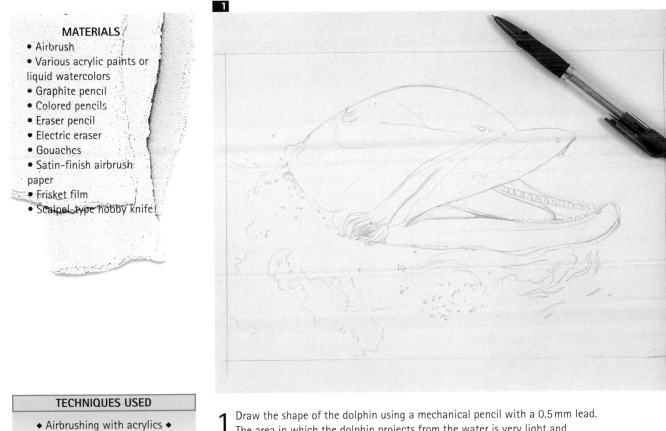

1 Draw the shape of the dolphin using a mechanical pencil with a 0.5 mm lead. The area in which the dolphin projects from the water is very light and strongly silhouetted. It's a curved outline with a large snout sticking out of the water. The area below the water has a fuzzy shape that's altered by the undulations on the surface.

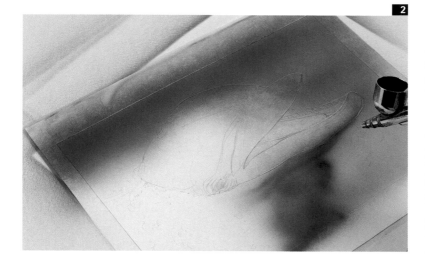

2 The first passes with the airbrush are done at a considerable distance, intensifying the blue in the areas where the water is darker or shaded. The only part blocked out is the dolphin.

BACKGROUNDS

Doing the background involves establishing a preliminary relationship of color and intensity, especially if it's the first thing you do.

It's important to compare the shades with the white of the paper to assess the initial relationships of contrast and color. The background, which takes up a large area, must be done using several passes and filling the paint cup as many times as necessary. In illuminated areas, the transparency to the white of the paper will be important if you don't want to do a lot of filling in to create a pure white.

3 The first effect of the shape in the water is created with a few passes over the transparent area near the dolphin's body where the shape shows through, using curved and vibrant lines that suggest the movement of the water.

4 Cover the background with frisketing and use the scalpel to cut out the inner part of the mouth. Uncover that area and color it in with straight black, for this is a very dark part of the image.

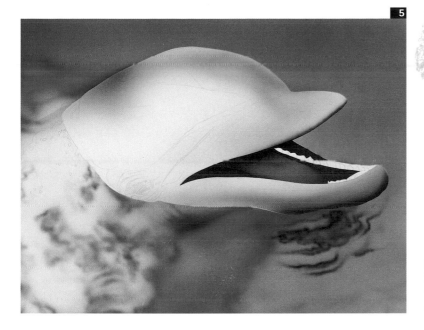

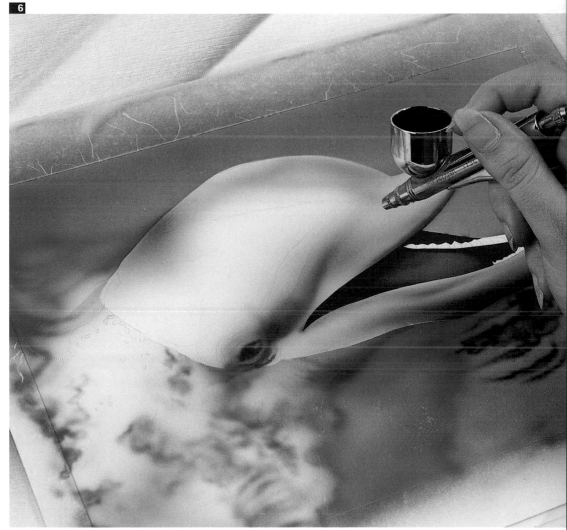

BLACK PAPER

Black is a very important color in contrast work and the overall tonal values of the image. The deepest black is established, and the rest of the shades are worked as a function of that color. For warm colors a sepia or an umber can be chosen; the cold shades, though, go better with black than with the umber and brown shades.

5 Now the silhouette of the dolphin is uncovered and sprayed with a gray shade leaning toward purple. Both the lower part of the jaw and the top of the back are sprayed especially dark.

6 The same color is used to intensify the furrow that runs from the eye toward the snout as a long field of color that gradually becomes fainter. The eye was drawn previously with a pencil to situate it and make it convenient to color in.

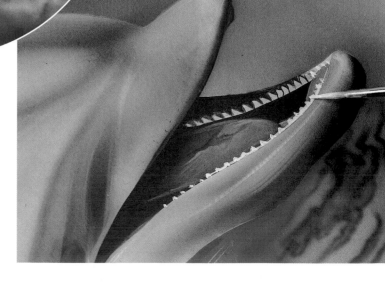

7 Color the entire surface of the dolphin with grays and purples, and then open up light areas in the most luminous parts where the skin shines, that is, at the corner of the mouth, where the color is lightened using an eraser pencil.

8 Begin to work the surface of the water with an electric eraser. As it is passed over the colored area, the color is removed in light, vibrant lines.

9 The teeth are worked one at a time with a fine brush and white gouache until the whole row is clear and well defined.

10 The main reflections on the water are done in straight white gouache. These dots communicate the brightest reflections of the sunlight.

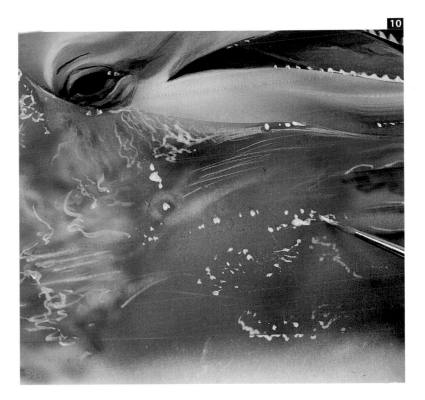

11 The final result is striking and very attractive, especially because of the reflections both in the crystal-clear water and on the creature's fine, smooth, and very shiny skin.

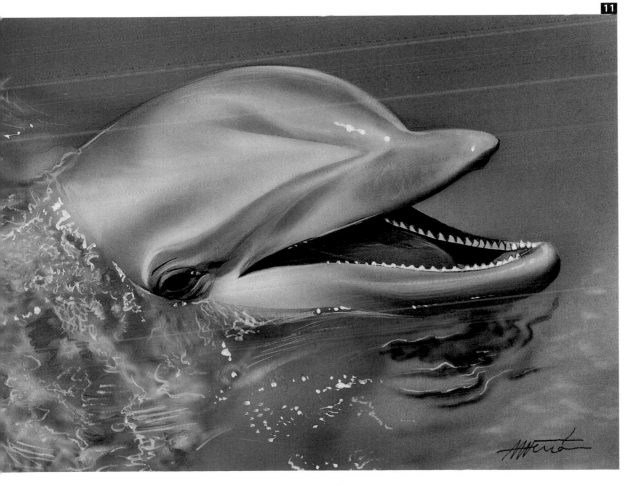

Portrait of a Child

Realistic portraits are a good subject for the airbrush, given the capacity of this tool for reproducing objects, figures, and especially textures in a realistic way. Portraiture¯is one of the oldest types of representation. Before the advent of photography it was the only form of depicting people, clothing, and other features. But this is not an easy subject, since any small error can result in a lack of resemblance to the original model. You have to analyze many features to represent the human expression adequately, such as the structure of the skull and the location of the facial muscles. The face and the jaw are fundamentally important; they may be totally relaxed in a passive expression, or under tension because of a smile or a sneer. A child's face typically presents softness and sweetness, some features that haven't yet developed, and hair that has not been subjected to the effects of time.

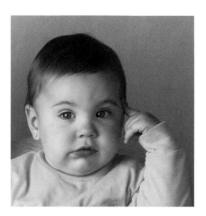

For this portrait we have selected the image of a little girl a few months old; because of her youth she has sweet, rounded facial features.

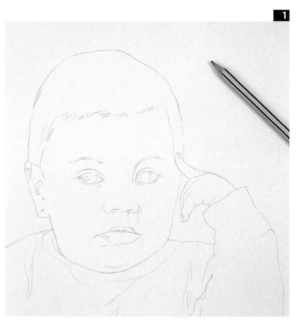

MATERIALS

- Airbrush
- Various acrylic paints or liquid watercolors
- Graphite pencil
- Colored pencils
- Black fine-tip marker
- Gouaches
- Satin-finish airbrush paper
- Frisket film
- Scalpel-type hobby knife
- Glue paint

1 The outline of the child starts as a line drawing without creating any volume. This includes only the outer shapes of the head, the body, and the hand, plus the inner features of the nose, the eyes, and the mouth.

2 The entire figure is covered with masking, and once it's cut out the part corresponding to the clothing is removed. Holding the airbrush at a distance, straight medium yellow is sprayed all over the T-shirt.

TECHNIQUES USED

- ◆ Spraying with acrylics ◆
- ◆ Using colored pencils for details ◆
- ◆ Opening up light areas with an eraser ◆

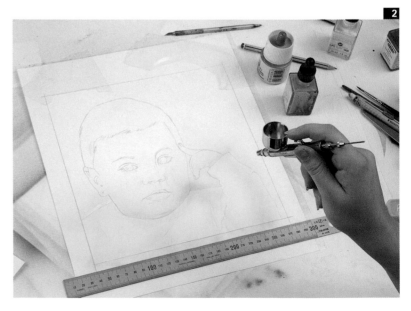

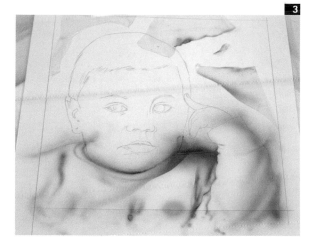

3 A natural umber color is used to darken certain sections of the jersey, especially the wrinkles and the shadows projected onto the left shoulder by the face.

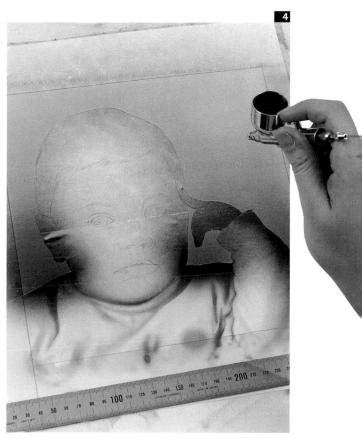

4 The jersey is once again blocked out with frisketing and the background is uncovered. Then, with the airbrush held at a distance a grayish gradation is applied from top to bottom.

ANALYZING THE MODEL
Direct observation of the model is essential for producing acceptable results. The resemblance, the brightness of the colors, and the strength of the contrasts will all have an impact on the final product.

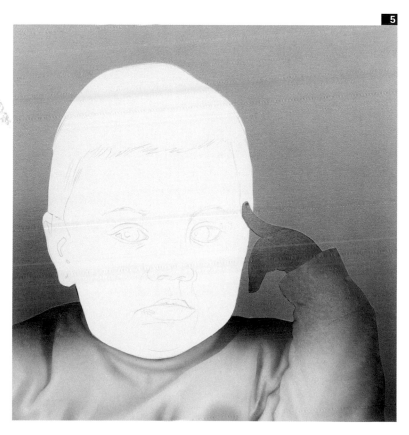

5 Remove the masking and note that the head is perfectly surrounded by the background and the jersey. The only things remaining are the flesh tones of the hand and the face, plus the color of the hair.

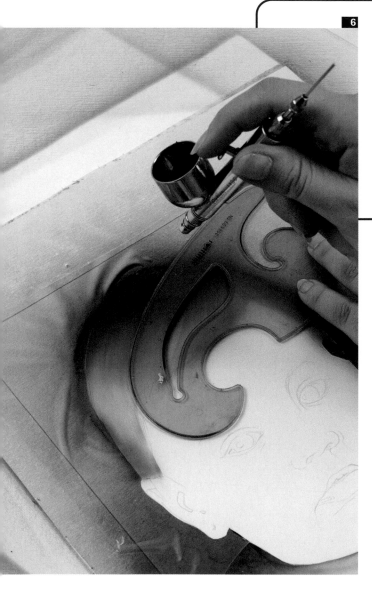

6

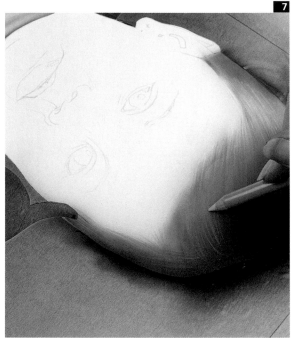

7

PORTRAITS AS SUBJECT MATTER
Portraits are difficult because even the smallest error can ruin the resemblance to the model. Many factors need to be analyzed in depicting human expressions, including the structure of the skull and the status of the facial muscles. The face generates all kinds of expressions and movements, and this is where the artist's skill in achieving a resemblance is displayed. A good portrait reflects the entire essence of the model, and a portrait done with an airbrush can achieve a high level of detail and resemblance.

8

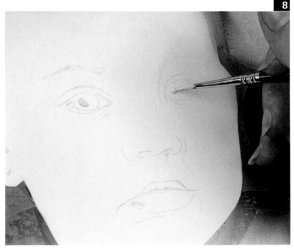

6 The upper part of the background is blocked out and the child's head is uncovered. Then dark brown is used to color in the top of the head where the main shadow is located. A curved template facilitates depicting the natural wave of the hair.

7 The blond locks are done using an ochre pencil. The colors stand out against the darkness at the top of the hair.

8 Glue paint is used on the smallest areas that correspond to the shine on the eyes and lips.

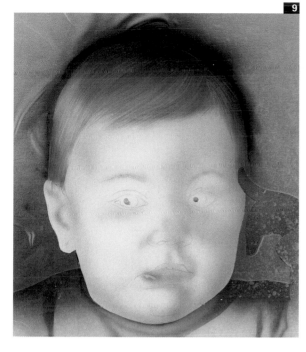

9 Cover the hair and use a shade of pink to begin working the shapes of the face and hand. The left side of the portrait is brighter, so the spray is more intense toward the right

10 Umber is used to darken the right side and establish the main divisions between the face and the ears, the nose, the chin, and the fingers of the hand.

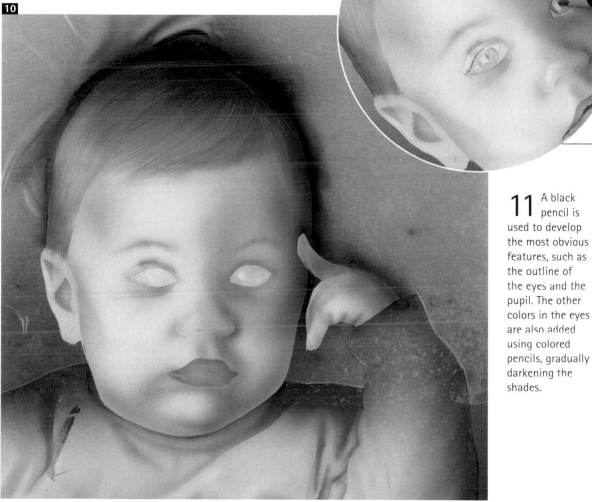

11 A black pencil is used to develop the most obvious features, such as the outline of the eyes and the pupil. The other colors in the eyes are also added using colored pencils, gradually darkening the shades.

12 Once the details of the eyes and mouth are done, the shapes are highlighted by using an eraser pencil on the most prominent areas, including the nose and the chin.

13 Finally, all the details and the shapes of the face are completed. The result is a soft and tender image appropriate to a young child.

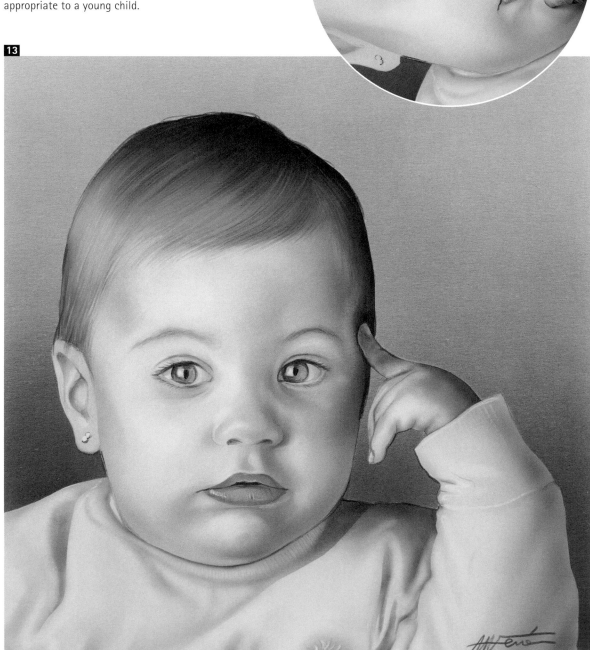

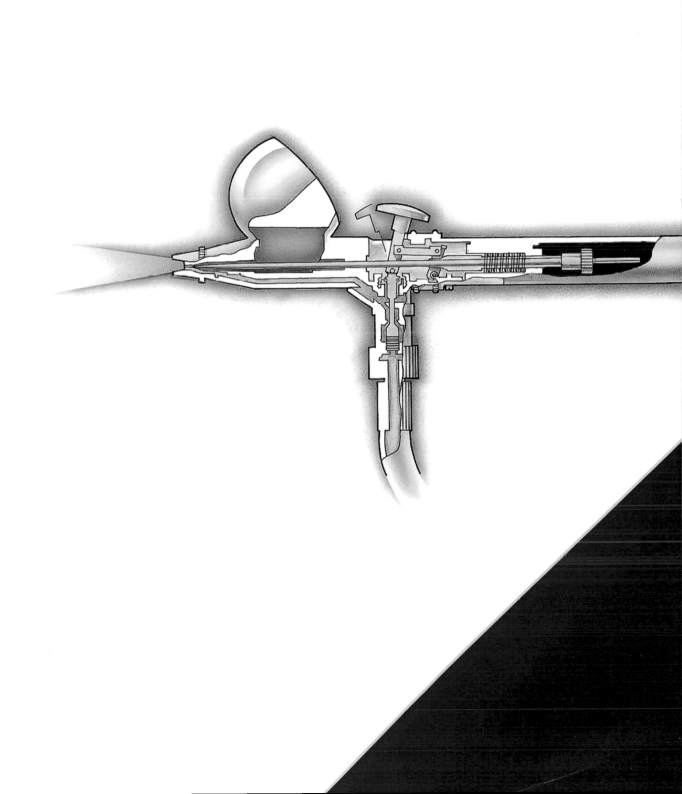

Related Barron's titles on this subject:

The Acrylics and Gouache Artist's Handbook
(ISBN 0-7641-5621-7) Barron's Educational Series,
Inc. 2003

All About Techniques in Airbrush
(ISBN 0-7641-5509-1) Barron's Educational Series,
Inc. 2002

Art Handbook: Portraits
(ISBN 0-7641-5108-8) Barron's Educational Series,
Inc. 2002

Art Handbook: Airbrush
(ISBN 0-7641-5161-4) Barron's Educational Series,
Inc. 1999